WILTS & BERKS CANAL

CANAL

THROUGH TIME

Doug Small

AMBERLEY PUBLISHING

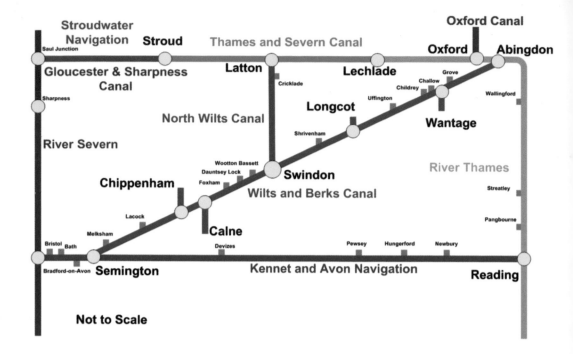

When the canal is restored it will form the central part of a Wessex Waterway Network, opening up a vast amount of countryside as a public amenity. Boaters are only a very small proportion of waterway users: the majority are ramblers, fishermen, cyclists, photographers etc. Waterways also provide an excellent wildlife habitat.
(For convenience in descriptions I have used east/west for the Main Line of the canal and north/south for the North Wilts).

First published 2012

Amberley Publishing
The Hill, Stroud
Gloucestershire, GL5 4EP

www.amberley-books.com

Copyright © Doug Small , 2012

The right of Doug Small to be identified as the
Author of this work has been asserted in accordance
with the Copyrights, Designs and Patents Act 1988.

ISBN 978 1 4456 0952 2

British Library Cataloguing in Publication Data.
A catalogue record for this book is available from
the British Library.

Typeset in 9.5pt on 12pt Celeste.
Typesetting by Amberley Publishing.
Printed in the UK.

Introduction

The Wilts & Berks Canal owes its continued existence to its extremely rural nature. An urban canal abandoned a hundred years ago would soon have disappeared under the developer's shovel. But although the canal's country nature preserved much of the route, it is a major problem for us when looking for images of a working canal. Compared to other waterways the Wilts & Berks might as well have been invisible during the nineteenth century. We know that some photographs were taken; Henry de Salis is probably the best known. Richard Blunt, in his account of a trip on the canal in 1892, mentions having a good collection of photographs; unfortunately they do not appear to have survived. So, apart from a few images, the working life of the canal is almost completely visually unrecorded. For over six decades after abandonment several dedicated individuals explored and photographed its slowly decaying remains, which were in stark contrast to today's view of the exciting new future that is now emerging. What we now have is a record of the twentieth-century canal showing it through its years of decay and isolation up to a bright new future in the twenty-first century, where the canal is being restored in many areas and new sections have been built and others are in various stages of planning and implementation. Even so, before and after pictures can still be a problem. Where we are fortunate enough to have a 'before' (e.g. a rural bridge), the 'after' is often just a non-descript road in the middle of nowhere and an old, remote lock cottage may now just be a patch of grass. Occasionally, a little gem does surface (see page 31).

The Wilts & Berks Canal was first proposed in 1793, near the end of the era known as 'canal mania' which had seen the rapid expansion of Britain's inland waterway network. An Act of Parliament in 1795 allowed work to start at Semington and by 1810 the route was complete to Abingdon. This linked the newly completed Kennet & Avon Canal (also opened in 1810) to the River Thames. There were also branches to Chippenham, Calne, Longcot and Wantage. In 1819 a new canal was built between the Wilts & Berks Canal in Swindon and the Thames & Severn Canal near Latton which enabled boats to avoid the difficult Upper Thames navigation, something that had been suggested many years earlier. The North Wilts Canal, as the nine-mile waterway was known, was soon in financial difficulties and was taken over by the Wilts & Berks Canal Company.

The Canal enjoyed a few years of moderately successful trading, including carrying materials for the Great Western Railway when it was under construction in the 1840s. After that the rivalry between the two modes of transport intensified and eventually most trade switched to the faster and more convenient railway. Several abortive attempts were made to revive the trade on the canal, as were attempts to have the canal closed: none were successful. One reported attempt to have the canal abandoned had the wholehearted support of Swindon residents wishing to have the 'stinking ditch' removed, but was not supported by either the Town Council or local landowners. The landowners were concerned that they would lose their 'valuable water resource'. In 1901 there occurred a fortuitous event which allowed the canal company to apply again for an Act of Abandonment. This was the partial collapse of Stanley Aqueduct over the River Marden, between the Chippenham and Calne junctions. It severed the canal and prevented any through traffic. The company, pleading poverty, was unable to repair the breach. Due to a condition in the original Enabling Act, a period of thirteen years was to pass before the canal could legally be abandoned. In 1914 the defunct waterway was either sold off or returned to the original landowners. There now began a protracted period of gentle decay. Most of the canal line lay in remote countryside and where it was not filled in and ploughed over it was soon covered with dense undergrowth which completely hid it from view. In the towns the water soon disappeared and the canal bed became a convenient place for

rubbish disposal. This rubbish, combined with the muddy, stagnant canal, was considered a health hazard and infilling soon began, although the canal line was never completely obliterated.

After abandonment, one of the few remaining signs of the old canal was the occasional hump back bridge but even these were eventually to disappear under road widening and upgrading schemes. So it would have continued until all traces had disappeared had it not had been for the Inland Waterways Association (IWA). Formed in 1946 to protect the canal network from almost complete destruction by an unsympathetic government, it grew in strength over the decades and by the late 1970s was achieving considerable success in reviving 'lost' canals. In 1977 the forgotten Wilts & Berks was 'discovered' almost by accident and soon a society was set up with the aim of preserving its remains. Eventually this aim became a plan to fully restore the canal, using as much of the original route as possible. Thirty-five years later and the restoration is now the longest and probably the most ambitious in the country. There are many difficulties, not least the problem of development of towns such as Swindon, Abingdon, Wantage and Melksham, and the newly built and upgraded roads (including the M4 and the A34), as well as the need to cross the railway in three places. There are of course solutions to all of these problems; all that is required is the planning permission and the finance!

The re-emergence of the canal has become very apparent in the last few years and significant progress has been made in several areas. The Wilts & Berks Canal Trust (WBCT) is very proud to have the Duchess of Cornwall as their Patron, a role she fulfils with great charm and enthusiasm. The Wichelstowe development in Swindon is an example of how progress can be made. As part of the housing development a new section of canal was constructed, including a fully functional lock, which will eventually form part of the main line of the canal, taking it on a new route south of Swindon. The canal will follow the M4 until it passes under the A419 and then turn north to eventually meet the original line near Bourton. In order to achieve this it will need a series of new locks, up and down, which will take it over the high ground near Coate Water which was the original reservoir for the summit of the canal. The proposed new Melksham Link project which is due to commence 2013/14 is another example of how new developments can aid restoration. This link will be another new section of canal from the Kennet & Avon Canal to the River Avon where the river will be used to pass through the town. The Trust has also purchased a new steel trip boat which operates regularly at Westleaze. Another recent Trust initiative is the project for a continuous footpath along the canal, using as much of the original line as possible.

While the canal is being restored, some of the remaining features are still being lost. The most significant losses recently were most of the buildings and structures on Wantage Wharf. It was inevitable that a prime site in the centre of the town would eventually be built upon, especially as there was no prospect of it ever having the canal there again. Only the Wharfinger's house and the Sack House survived. Tragically, everything else disappeared almost overnight apparently with no archaeological survey having been carried out.

A partnership of many organisations, (including councils, companies, associated voluntary organisations, etc.) has for many years guided the restoration, although most of the work 'on the ground' is still undertaken by WBCT volunteers.

On 2 May 2012 *The London Gazette* confirmed, 'Her Majesty The Queen has been graciously pleased to confer Her award in 2012 upon the following group in recognition of their outstanding voluntary work in the community.'

The Queen's Award for Voluntary Service

The MBE for volunteer groups

The Wilts & Berks Canal Trust - The Queen's Award for Voluntary Service 2012

Abingdon to Swindon

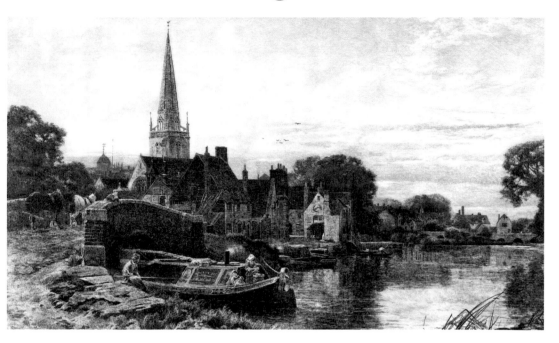

A narrow boat is waiting to enter the lock which is on the other side of the bridge, *c.* 1860. The two horses may indicate that another boat was already locking through.

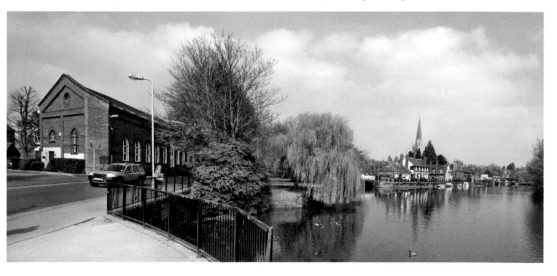

The old canal entrance is still obvious and the Environment Agency has erected an information board, which is only easily visible to boaters, at the site. All of the old wharf buildings have now gone, although local residents insist that the lock is still buried intact under the tarmac. Over the years the town has grown, the Basin has been infilled and the route of the canal built upon, although it is still possible to trace it to the outskirts by following near forgotten footpaths. 2011.

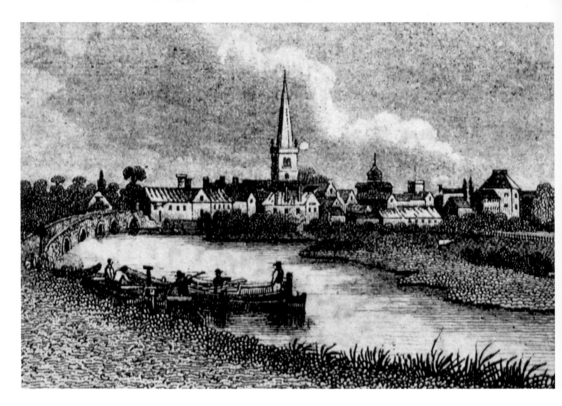

The stone arch bridge is over the River Ock and is seen in 1815. It was replaced by the Canal Company in 1824, with a cast iron bridge from Acramans, giving easier access to the canal wharf.

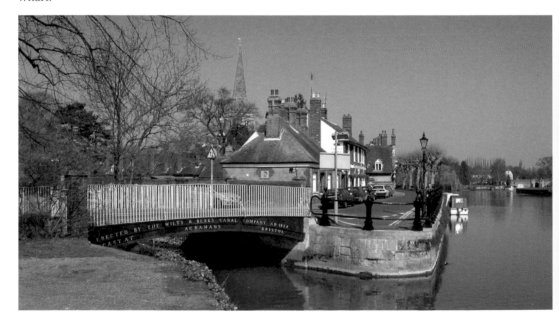

The 'new' 1824 bridge still stands today, almost exactly as when first built, except for having been widened a few years ago to cope with modern traffic. This photograph was taken in 2011.

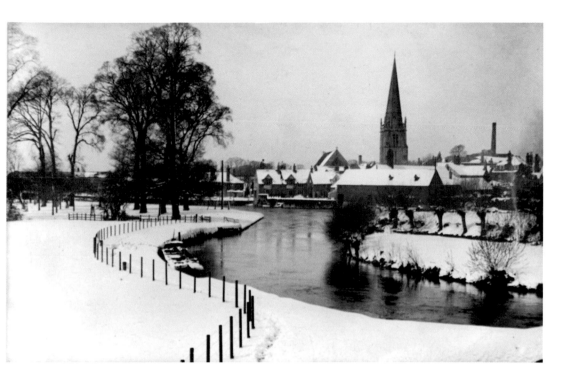

Upstream from the canal entrance a narrow boat is moored on the river, just below the bridge, in around 1900. The river is frozen – not uncommon in Victorian times. No doubt the canal was also solid with ice, causing great hardship to the boatmen.

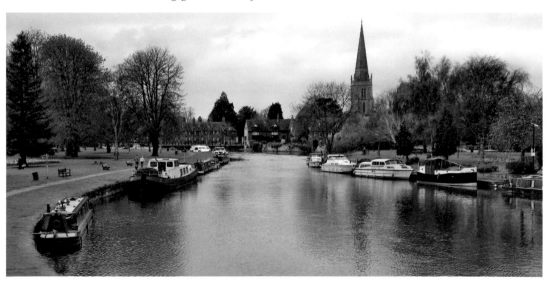

The narrowboat is moored in the same position in 2012, only this time it's a pleasure boat. Commercial carrying is now almost non-existent but the increasing number of cruisers is putting pressure on the cruising network so that the extra 60 miles of the Wilts & Berks Canal will be a welcome extension.

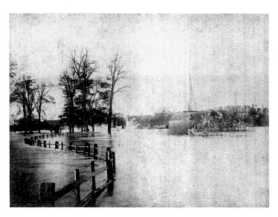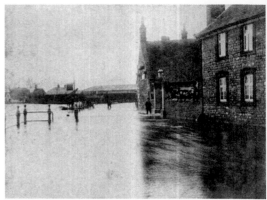

One problem with rivers is the possibility of flooding, which can seriously hamper the movement of boats, especially the horse-drawn narrow boats that were used on the canal. These images both date from around 1880. Left: Looking downstream from Abingdon Bridge. Right: Looking towards canal junction and the Old Anchor pub.

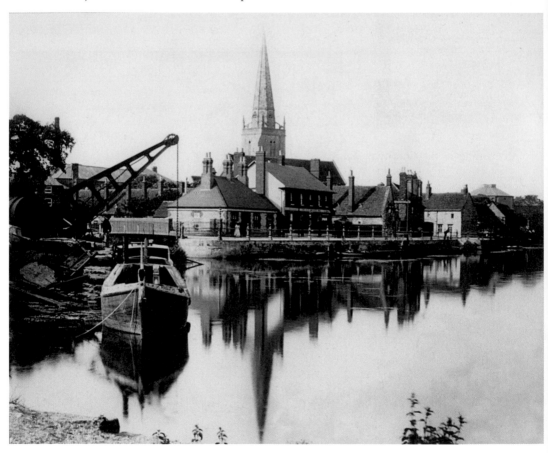

A thriving boat building business was established close to the junction. The canal entrance is just to the left in front of the narrow boat in this photograph from around 1890. (Picture courtesy of The Keasbury-Gordon Photograph Archive)

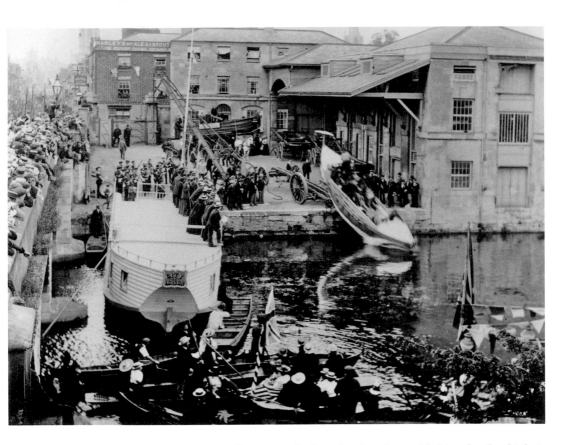

According to the County Records Office at Oxford, Richard Parker sold this wharf, which is adjacent to Folly Bridge in Oxford, to the Wilts & Berks Canal Company on 3 July 1844 for £1,800, plus £229 10s 0d for cranes etc; the bill was eventually paid on 22 October 1844. In this image from around 1900 the wharf was owned by Salter Brothers and the crowd were gathered to watch the launching of a lifeboat.

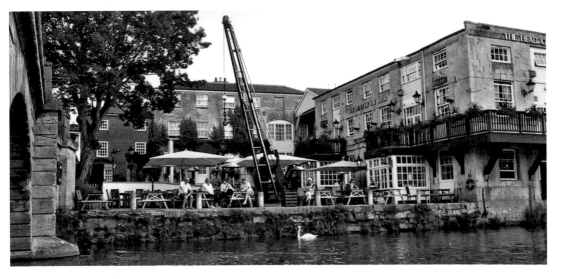

In 2012 the wharf and buildings serve Oxford as a waterside hotel and restaurant.

By the 1920s the canal basin was almost completely dry, although the draw bridge at the entrance was still in place. The detail from the inset drawing gives an impression of what the bridge looked like during the working life of the canal.

1946 and the basin has been filled in and apparently grassed over. Caldecott Road runs alongside the canal line and housing has started to replace some of the open areas.

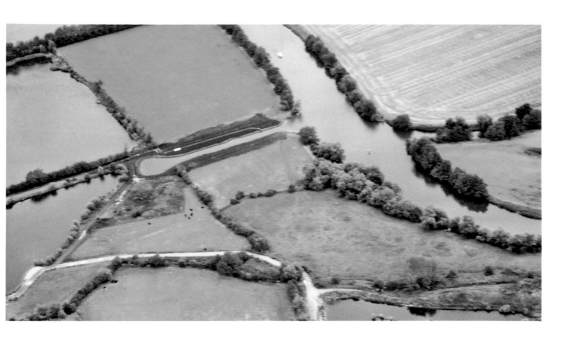

If the canal is ever to be restored then a new junction with the River Thames needed to be found. This is located about a mile downstream from the original junction opposite the cut to Culham Lock. Eventually the junction will be extended through the lake, on towards and under the A34 to rejoin the original canal line.

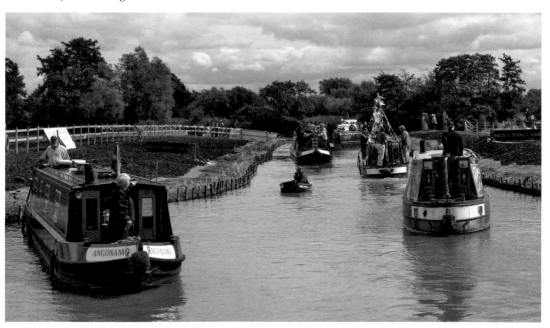

30 August 2006 was an historic day for the Wilts & Berks Canal Trust. After two years of planning and a great deal of hard work by Trust volunteers, the Waterway Recovery Group and White Horse Contractors, the new Jubilee Junction was finally open. A parade of boats enters the new canal from the River Thames to mark this historic event.

Looking west down Abingdon's filled-in basin in the 1960s. Just visible at the far end, new housing has started to appear although even today (2012) the basin remains clear and the adjacent field is still a sports ground.

The original route out of Abingdon is still relatively easy to follow although it does become more adventurous after leaving Caldecott Road (left). Although a public footpath, its passage through local housing does tend to get neglected (right). Fortunately the local ramblers recently ensured that all these obstructions were removed.

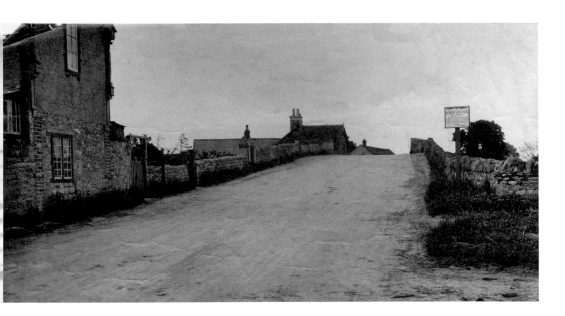

Drayton Road Bridge was in a precarious state and in danger of collapse when the top photograph was taken in 1912. It was being supported underneath with wooden scaffolding and the notice board states: 'County of Berkshire to all Traction Engine Drivers and others. Take notice that the Berkshire County Council has been advised that this bridge, for the maintenance and repair of which the Wilts & Berks Canal Company are responsible, is not sufficiently safe to take more than light traffic.'

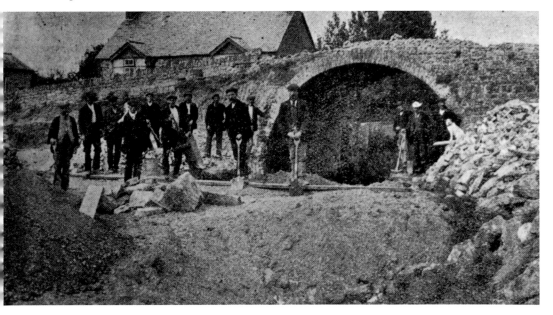

Within a year it had obviously been decided by the canal company that the bridge had become too dangerous and it was demolished, as shown in the photograph by G. Harper in the *Oxford Journal Illustrated*, dated 11 June 1913.

As recently as 1975 Tithe Barn Lock was still relatively intact, although overgrown and filled with rubbish. Since then more houses have been built and what remains of the lock is now buried under the gardens.

This is said to be the base of a Second World War anti-aircraft gun emplacement built on the canal line and still firmly there in 2007.

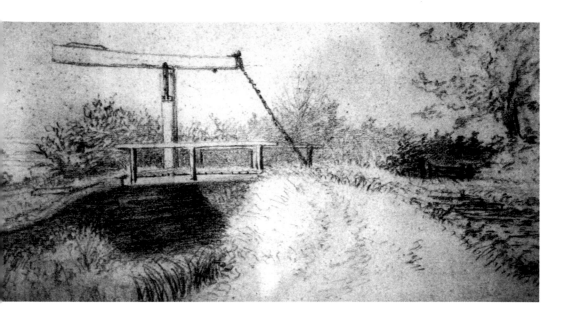

Once clear of Abingdon and beyond the A34, the canal resumes its rural character. Drayton Lock once had a typical lift bridge. No trace of the bridge remains and the lock chamber is in a very bad condition.

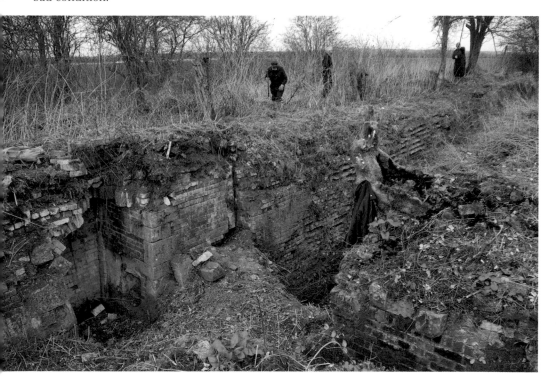

Volunteers make periodic visits to the lock to remove the overgrowth and generally monitor its condition, but any restoration work is on hold until a final decision regarding a new reservoir is made. If built, a reservoir could possibly encompass three lock sites and require the re-routing of the canal.

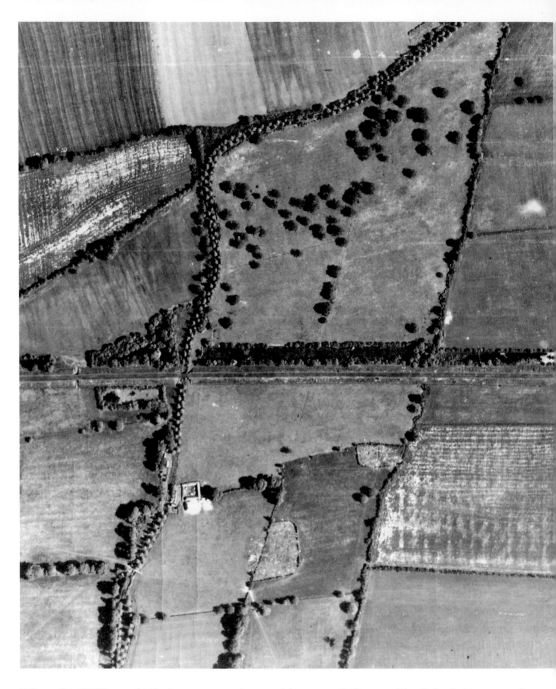

When the GWR was built, it cut across the canal between Ardington Marsh Lock (top centre) and Ardington Top Lock (bottom left). The canal is clearly marked by the tree line running up the picture, which dates from around 1946. This peaceful, secluded location, which also included a small farmstead (Ardingtonmead) close by the top lock, was from then on to be subjected to the noise of the passing trains. There was also a lock keeper's house at the top lock as well as a primitive cottage opposite to the farm. The railway bridge over the canal has now been filled in, but just adjacent there is still the farm track bridge, which could possibly be used to take the canal instead.

Ardington Marsh Lock is still remarkably well preserved in this image from 2012, with the remains of one gate still in position. This being one of the locks under threat from the possible reservoir project, no restoration work is currently being planned.

In February 1974 Ardingtonmead farm was still there, although only just visible because of the glare from the sun. This picture was taken from the track of the main line looking west – not the most sensible place to stand!

The row of trees marks the line of the canal, seen here in 2002, under the railway embankment which was filled in many years ago. A possible way through is an adjacent farm track, which is one of several in this location.

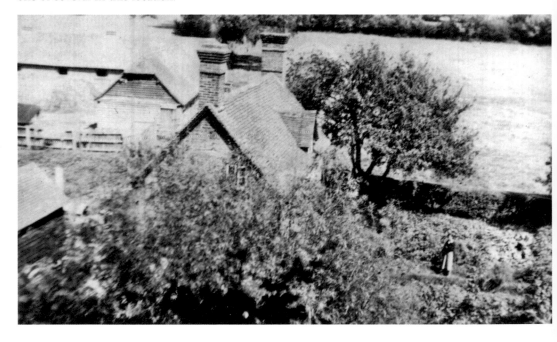

All the Ardingtonmead Farm buildings are now gone, although building rubble turned up by the plough often marks the site. No sign of the cottage remains. Dolly Rivers, one of the last people to live at the farm, is seen here in the garden in about 1955. With no road to the farm, it is almost impossible to imagine just how remote a location this was. Visitors and tradesmen had to walk down the towpath from Pinmarsh Bridge on Grove Park Road, the road which was built especially for Lord Wantage to give him easy access to Wantage railway station.

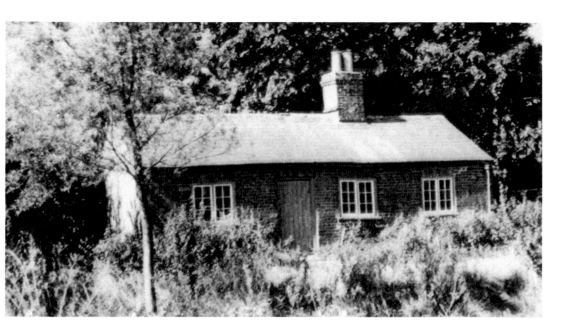

There is no sign of the primitive cottage in which 'Great Uncle Jim' once lived, although it was still standing in the 1960s. The cottage lacked all conveniences; even fresh water had to be carried from the farm, and that was also where the 'privvy' was located.

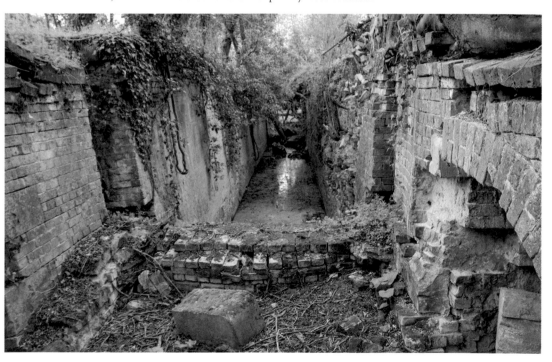

Ardington Top Lock is in much the same condition as Ardington Marsh Lock in this photograph from 2012. No restoration has yet been carried out on this structure but when the time is right, and with landowner permission, it will be a straightforward project. By the side of the lock there are the remains of the lock keeper's cottage, one wall of which still stands.

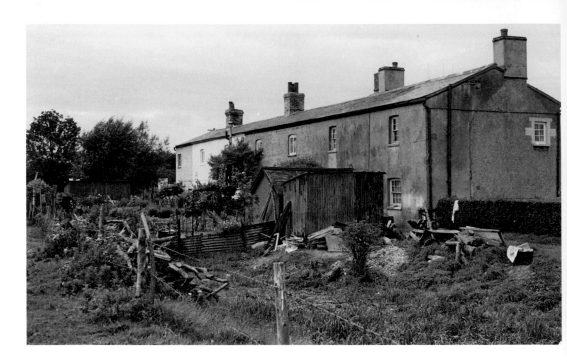

These cottages were erected in about 1810 for canal company workers. At one time they were inhabited by a carpenter, boatman and blacksmith, with a stable at the end. For many years up until 1946 they were owned by the Ormond family, hence the name 'Ormond Terrace'. The canal ran past the rear of these cottages. After the abandonment of the canal, it appears that the gardens have, rather untidily, encroached on the canal bed in this image from around 1950.

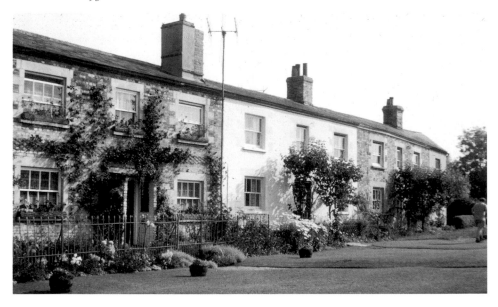

The cottages face the Oxford Road and from 1875 to 1947 the Wantage tramway ran past their front doors. The cottages present a very pleasant, 'country cottage' face to the world in this photograph from around 1965.

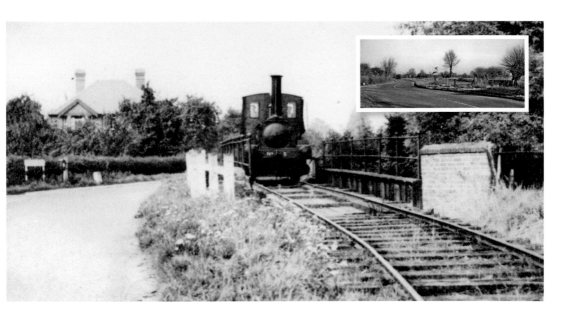

Wantage Tram No. 5 crossing Grove Bridge in around 1939.

Inset: 1960 and there is no sign of the tramway.

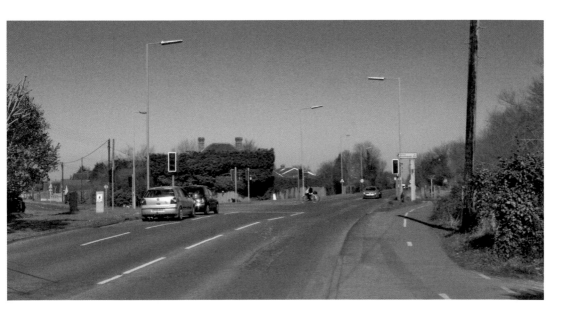

The Grove Bridge site in 2012, now the very busy A338.

(Left) Looking from the church tower of Saints Peter and Paul at Wantage Wharf in around 1890. (Right) The same view in the 1960s. The wharf and buildings are still there but housing has started to encroach.

Sainsbury's car park is built over the old tramway yard and the new buildings to the left of it mark the old wharf site in this image from 2008.

Wantage Wharf, looking back towards the Church of Saints Peter and Paul. There does not appear to be much activity on the bank in this image from around 1900 and the basin is badly weeded up. The crane on the wharf eventually ended up in the tramway upper yard; what finally became of it is not known.

Although the wharf, seen above in 1953, ceased to function with the closure of the canal, it remained fairly intact until the beginning of the twenty-first century when developers acquired it. Most of the remaining buildings have now disappeared.

The wharf continued to be used for a variety of purposes, including vehicle maintenance. In this picture from about 1980 the wharf entrance, Sack House and church can be seen on the far right.

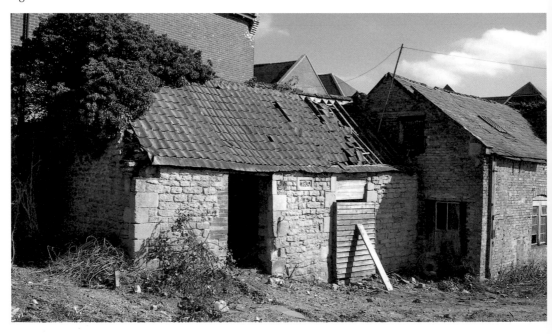

The old stables and workshops were finally demolished early in the twenty-first century to make way for the new housing estate.

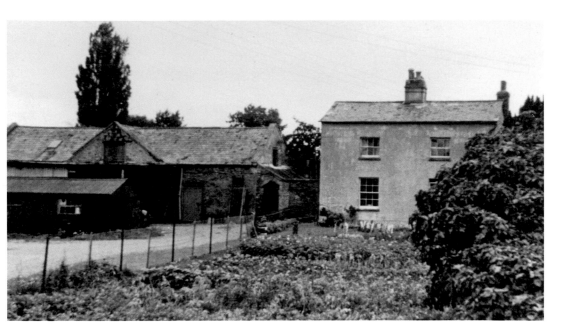

Seen here in the 1950s, the Wharfinger's house and workshops had dominated the wharf for nearly two centuries. It was from here that the day-to-day business was organised.

The wharf area, almost in the centre of Wantage, proved to be just too irresistible to the developers. The only survivors are the Wharfinger's house (looking completely lost in the modern development) and the old Sack House.

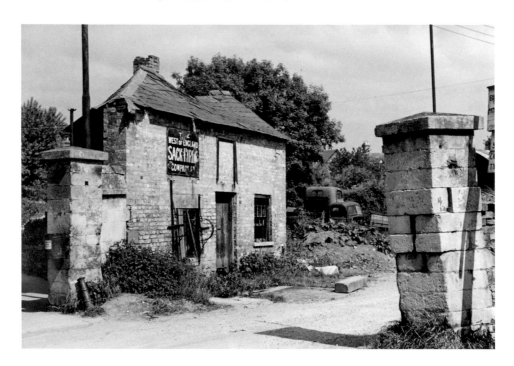

Sack hiring started early in the nineteenth century to enable corn merchants and farmers to transport their products the much longer distances that became practical with the coming of the canals and later the railways. Although not a listed building, it was saved by local campaigning with the support of the Canal Trust.

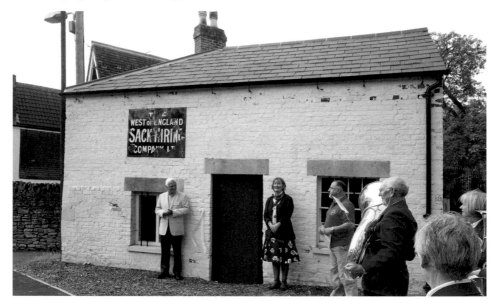

The developers, Barratts, sold the Sack House to the Canal Trust, who hope to refurbish the interior and use it as an information centre. The building was officially accepted in June 2012 at a ceremony presided over by Wantage Deputy Mayor Fiona Roper and John Laverick, Chairman of WBCT. Brian Stovold, in the blue shirt, chairman of the East Vale Branch of the Trust, played an important part in saving this building.

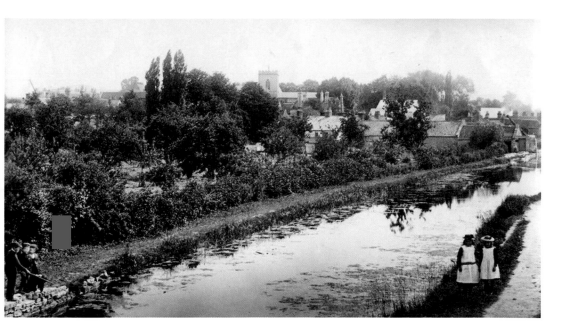

The short branch of the canal from the main line into Wantage had been very important to the town's development. The wharf was one of the final areas to continue working in the declining years of the navigation. But, as can be seen here, by the end of the nineteenth century its use was more recreational than commercial.

Looking towards Wantage along the branch with the church tower in the distance in June 1961. It had not yet been built on but had been infilled in places. This area is now covered in housing estates although the footpath through them still follows the canal line.

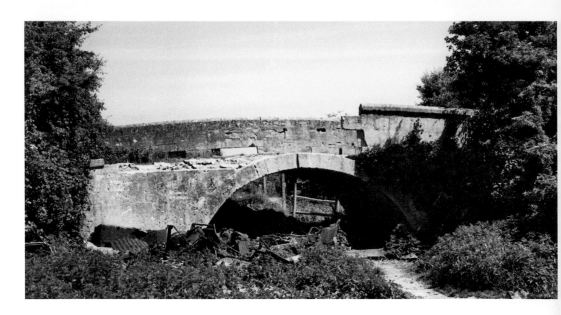

May 1961. A rather sad looking Belmont Bridge still stands over the infilled Wantage arm, which has now become a convenient rubbish dump. Samuel Worthington owned the land on which the bridge was built and insisted upon 'a commodious and substantial carriage bridge over the Wantage branch in view of Belmont House'. Belmont House was demolished in 1812! Until quite recently the remains of Belmont bridge straddled Belmont path, and one abutment can still be found lurking in the undergrowth.

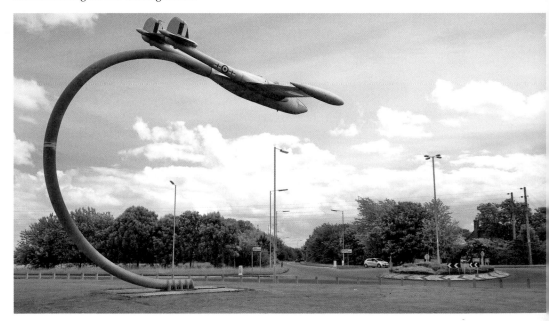

The site of the Wantage Arm junction in 2012. Grove Top Lock is hidden behind the trees to the left, and the junction was just behind the silver car. The aircraft (a de Havilland DH.112 Venom) is on the edge of the old Second World War Grove airfield. Ironically, it is close to the site where a Vickers Windsor attempted an emergency landing on 2 March 1944, overshot the runway and ended up with its nose in the canal.

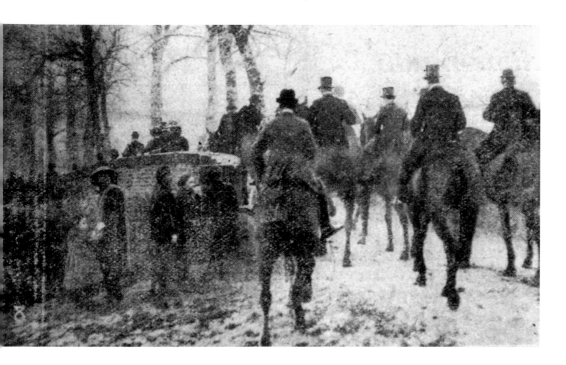

The Old Berks Hounds on Childrey New Road Bridge in January 1913. The story in the *Oxford Journal Illustrated* is about whether or not the weather conditions were bad enough to have the hunt abandoned. The interesting feature as far as the canal is concerned is that this is the only known picture of this bridge.

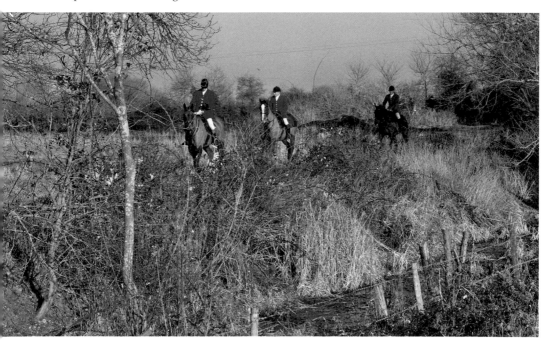

Slightly west of Childrey New Road Bridge in around 2000, the same hunt is still out and about, this time galloping along the towpath side of the canal, which volunteers have just started to clear.

Local headmaster Mr Bingham, on Uffington draw bridge in 1907. Intrepid explorers (with landowners' permission) can find the remains of the bridge still in place.

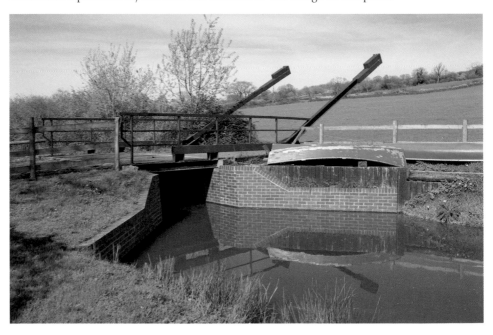

As the restoration of the canal progresses, many of the old bridges will need to be replaced. This one near Foxham, seen here in 2011, was built by volunteers and, although constructed in steel, closely follows the old design.

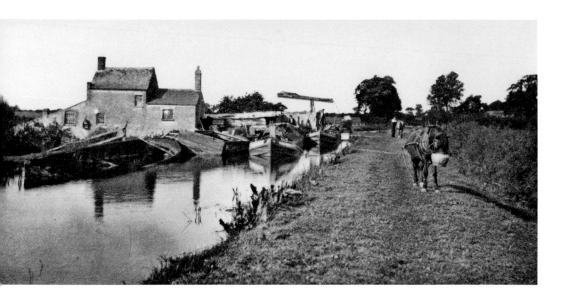

Uffington Wharf. This is the only the second known picture of working boats on the Wilts & Berks with their horses attached. The boats are facing east and loaded with cargo. Many small wharves such as this existed along the canal, serving local requirements. One reason that the canal was never really a financial success was the lack of agricultural back cargoes, which meant that boats regularly made return journeys empty or only partially loaded. The rectangular object floating alongside might be the remains of the abortive attempt to run 'sectionalised' boats on the canal. A similar one is floating in the 1895 picture of Wantage Wharf (p22, top left). This picture turned up in an 1893 American edition of *Tom Brown's Schooldays*.

Today the wharf buildings still stand, but a bungalow has been built on the canal line. The car is parked approximately on the site of the lift bridge in this 2011 image.

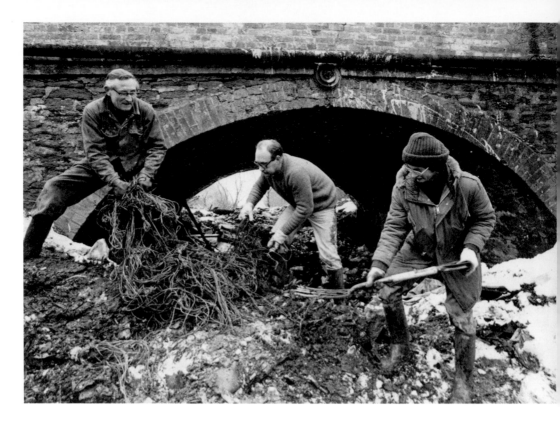

One of the first work sites for the restoration group was at Shrivenham Arch Bridge in 1980. Led by the founder of the Wilts & Berks Canal Amenity Group (Neil Rumbol, centre), the pioneering volunteers get stuck in. Ron Churchill can be seen on the left and Peter Boyce on the right. This was a massive task for the early volunteers, who even found a small car in the canal bed.

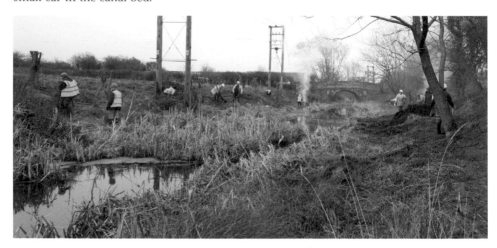

32 years later (January 2012), and after many thousands of man hours expended along the 60 plus miles of canal, the volunteers are back at Shrivenham Arch Bridge. This time the local group is assisted by a large contingent from WRG (Waterway Recovery Group). A much more professional operation but still carried out with the same determination.

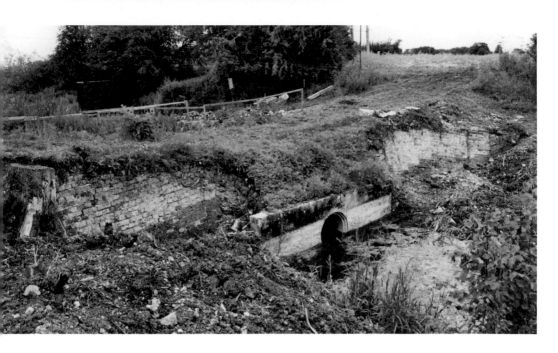

Steppingstone Lane Bridge carried a farm track and bridleway over the canal. It suffered the same fate as many of the other arch bridges, being collapsed and culverted. As was common practice, the arch was simply demolished and the rubble used on the trackway. The abutments usually remained in place, as was the case here. The undergrowth was cleared in about 2000 preparatory to rebuilding the bridge.

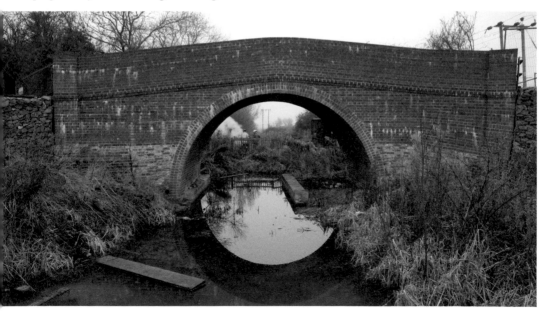

A team, lead by Trust volunteers and including members of Waterway Recovery Group assisted by volunteers from various organisations on 'team building' days, reconstructed the bridge to its traditional appearance, as seen here in January 2012. The bridge will be completed soon, when the new coping stones are placed in position.

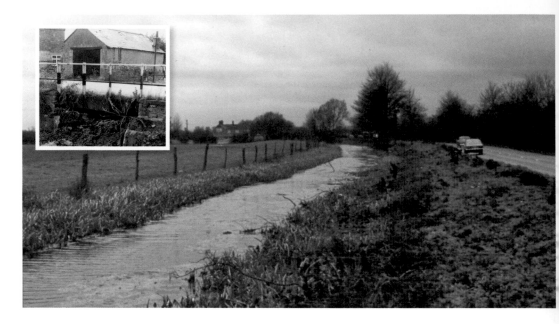

The canal ran west alongside the A420 towards Bourton Wharf and was still in water in the 1960s.

Inset: The old drawbridge was removed soon after the abandonment of the canal. There is a story that a young boy called George Carvey, aged four and a half, was drowned in the canal near here in 1861 and that somewhere on the canal bank a small stone memorial was placed. No trace of it has ever been found. This photograph is from around 1960.

The buildings are now residential, although the canal line can still be traced down towards Acorn Bridge. This image is from June 2012.

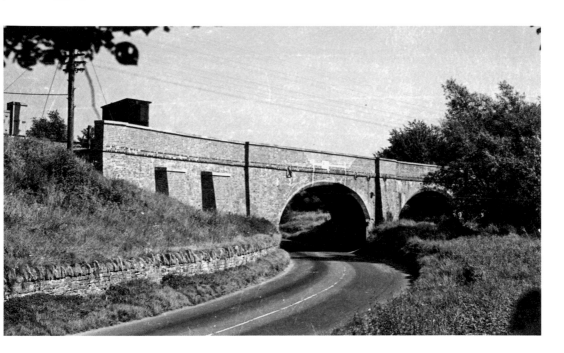

Looking east at Acorn Bridge, probably in the 1950s. The GWR viaduct spans the filled-in canal and the A420.

When the road was upgraded, the canal arch was used as the west-bound carriageway, as can be seen in this photograph from June 2012.

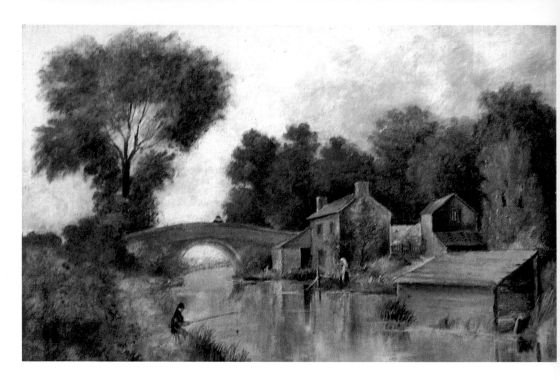

A typical rural scene on the canal at Stratton Wharf in the 1800s; only the trading narrowboats are missing.

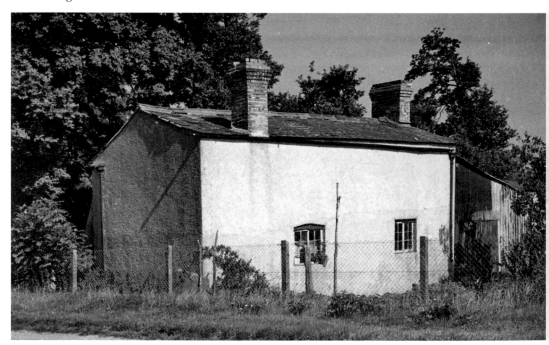

The forlorn looking wharf house seen from the rear in September 1960. Even this is now gone, lost among the urban sprawl. Plans to restore the canal do not include this section as the line will be diverted to the south of Swindon following the M4 corridor.

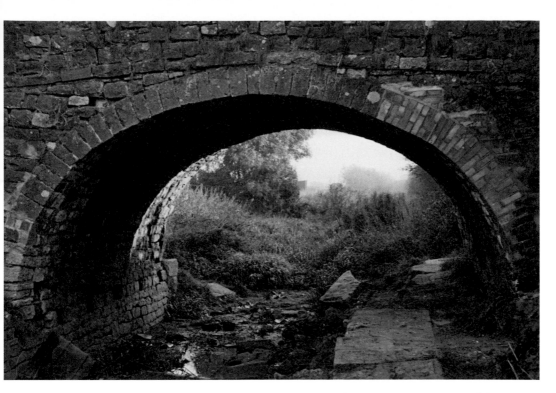

This bridge is a survivor. Marsh Farm Bridge, just east of Swindon's Magic Roundabout. The canal bed was infilled a few years after this picture was taken in June 1960.

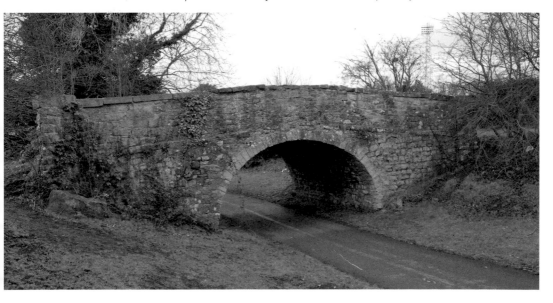

There was no need for the bridge to be retained but, proving that not all councils lack a heart, instead of demolishing the bridge it was renovated and still stands today in this photograph from May 2012, a small reminder of Swindon's lost waterway.

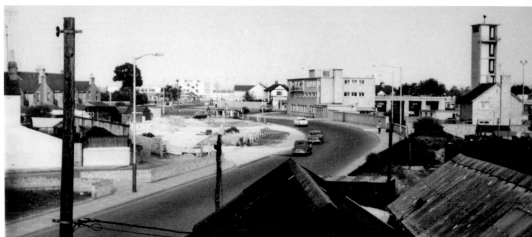

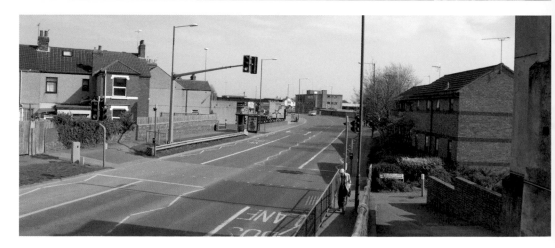

Three views looking east down the canal line (now Fleming Way) from the site of York Road Bridge towards the Magic Roundabout. Top 1950s; centre 1960s; and bottom May 2012.

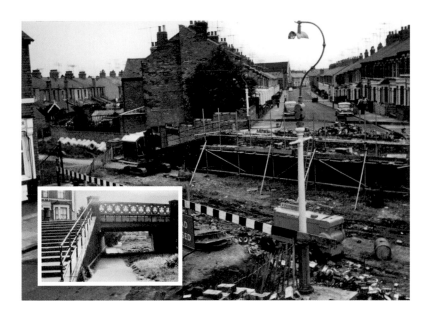

The rapid expansion of Swindon put a great strain on the road system and in 1961 the canal line was converted into a new road known as Fleming Way. The bridge was too low and the width of the trackway too narrow to allow it to remain, so Graham Street was severed from York Road by its removal.

Inset: York Road Bridge (also known as Graham Street Bridge) was built around 1907/08 by the Swindon Corporation, just a few years before the official abandonment of the canal. At this time the canal would have been no more than a smelly, muddy ditch, probably with a great deal of rubbish dumped in it. By the 1950s it was no more than a trackway. The bridge sides were of iron castings about an inch thick, with large trefoil perforations which both lightened the bridge and gave it a touch of elegance.

The abutments of the bridge still remain although the northern one has been moved to allow for the required road width in this photograph from May 2012. Fleming Way was named after Swindon football legend Harold Fleming (1887–1955).

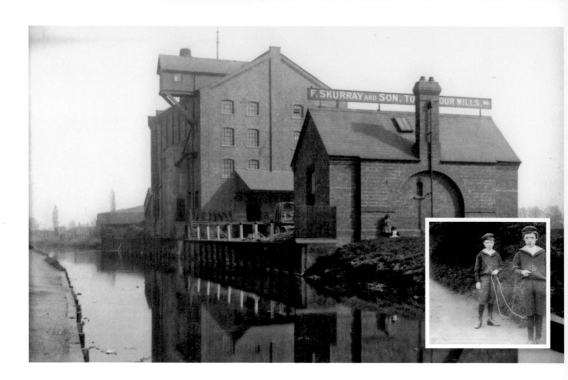

Skurrays Mill was just east of Whale Bridge. The canal is now part of Fleming Way. The two boys on the towpath opposite the mill in the inset photograph from about 1910 are Stanley and Leslie Richards, nephews of Swindon photographer William Hooper.

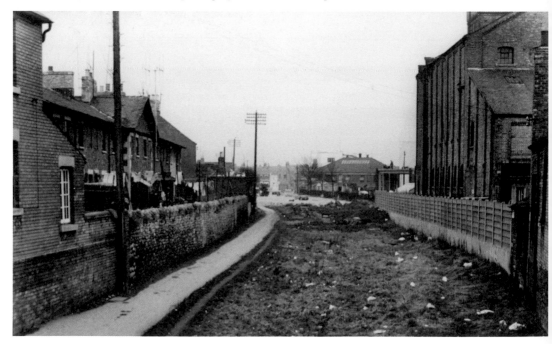

Not long after this photo was taken in about 1958 the mill was demolished and the canal became Fleming Way.

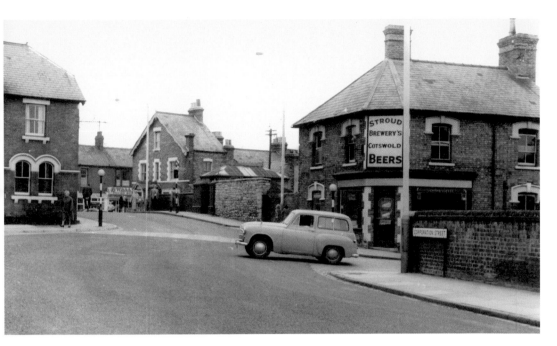

Corporation Street ran down from the railway to Whale Bridge and is seen here in about 1960.

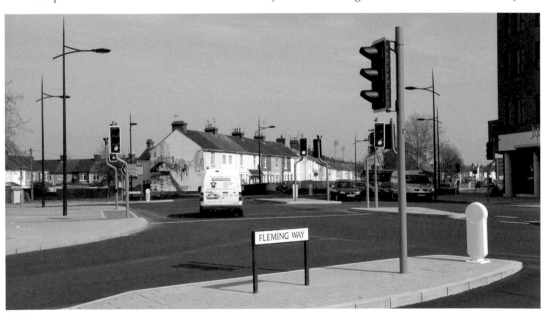

Corporation Street is to the left of this picture taken in May 2012, running away from the building with the mural painted on it. The white van is on the site of Whale Bridge. Skurrays Mill would have been on the right, along Fleming Way.

Swindon to Latton (North Wilts Canal)

With the opening of the North Wilts Canal in 1819, there was insufficient water on the Swindon summit to supply both it and the main line. The solution was to construct Coate reservoir, which opened in 1822, to supplement the existing sources. Today it is known as Coate Water Country Park. Most people now using the park would probably be unaware of its past and surprised to find that it was not a natural lake.

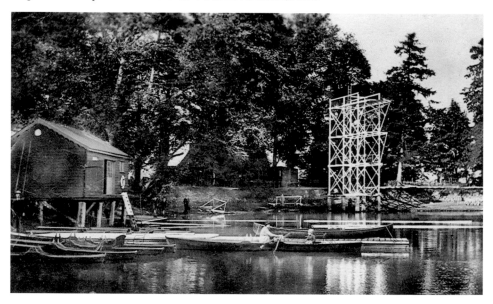

In 1914, with the canal abandoned, Coate became a pleasure park, with changing rooms and a diving board provided. The early diving board was replaced in 1935 with a concrete one measuring 33 feet (10 metres) in height.

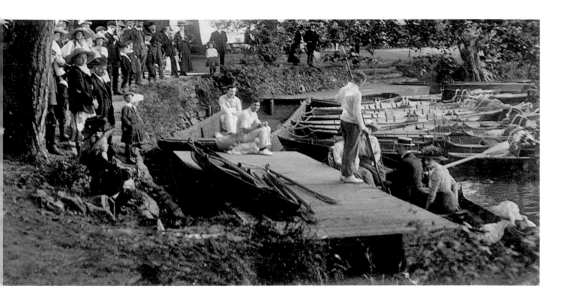

Even before the canal officially ceased to be, boating on the reservoir had always been a popular pastime as can be seen in this photograph from 1912.

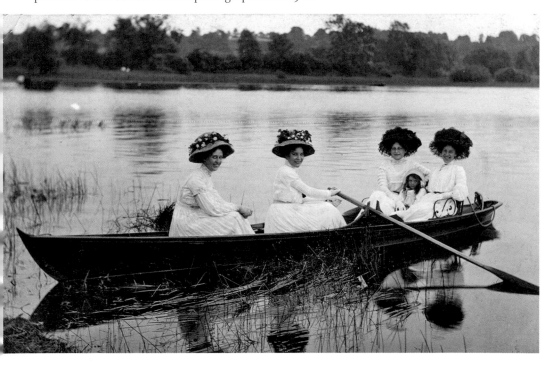

Rowing was just as popular with Edwardian ladies; this group is pictured rowing on Coate Water during August Bank Holiday 1910.

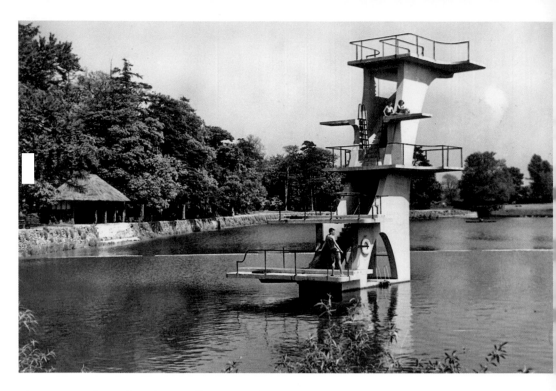

The concrete diving board was still in use in the 1960s.

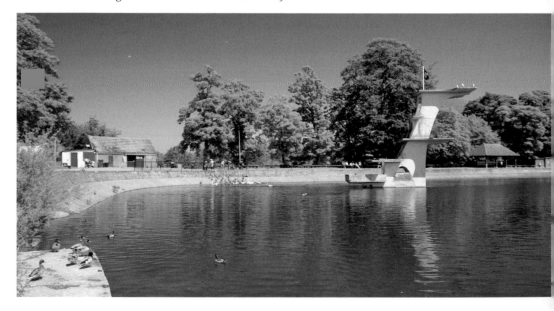

Use of the diving board is now forbidden and nobody appears to be interested in swimming in Coate Water any more in this photograph taken in May 2012. It seems strange that little or no boating now takes place on such a large expanse of water. Feeding the ducks and swans, and walking are apparently the main interests of the considerable numbers of people that visit the park.

As part of its restoration plans in the 1990s, the Canal Trust began clearing a section of canal north of the Purton road. This section included the derelict Moredon Lock and Moredon Aqueduct.

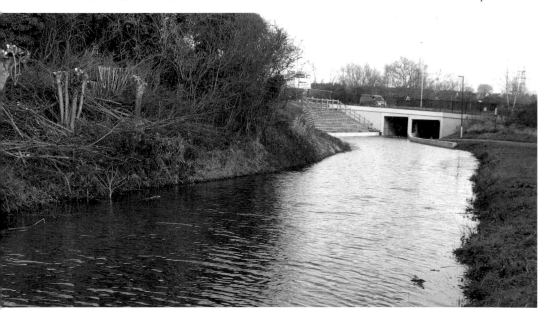

A road improvement plan meant that the road was realigned and raised, allowing for a navigable culvert and footpath to pass under it. The result can be seen in this photograph from about 2000.

Moredon Lock had been buried for many years. When it was excavated in about 1996, the remains of the bottom gates were found still in position. Just beyond the lock the canal has already been cleared and dredged, and the towpath re-instated.

In this image from about 2000 the rebuilt lock is just without its gates, which will not be installed until the canal is in regular use as they need to be kept wet to prevent them from shrinking and splitting.

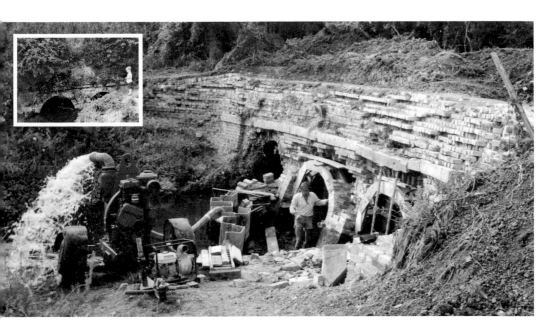

Volunteers stripped back and rebuilt all the damaged brick work, repaired the arches and cleared the canal bed in about 1996.

Inset: A young boy in the 1960s is seen peering at Moredon Aqueduct as it crosses the River Ray. The bed of the aqueduct at this time was infilled and overgrown and there was severe damage to the structure, although fortunately it hadn't collapsed, as this would have meant its removal.

The top of the aqueduct was landscaped and the parapet on the towpath side was rebuilt.

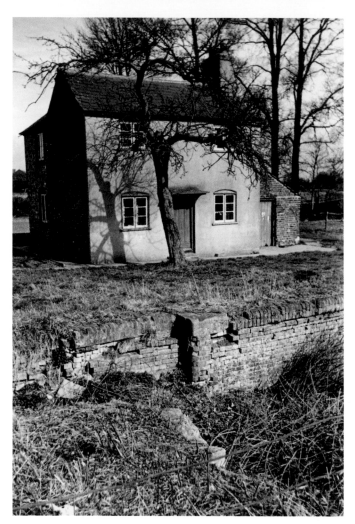

(Left) Crosslanes Lock suffered the same fate as most of the others on the canal. The lock soon became filled in and was probably robbed of many of the bricks for use elsewhere. It is seen here in about 1960.

(Bottom) By the 1970s the house was empty, but apparently under renovation. The most interesting feature in this picture is that the bridge (Woodwards) parapets are still in place and it shows that the road was flat (no hump), which makes its restoration much simpler.

(Inset) Shortly after, the house is occupied and there is no trace of the bridge.

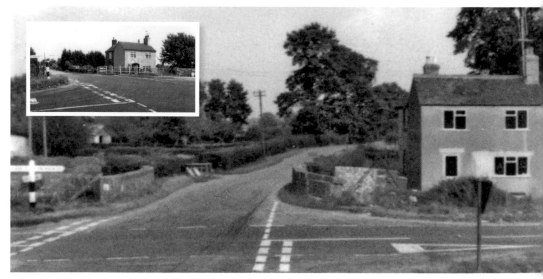

(Right) A reminder of what might have happened to the many miles of the rural canal left after the official abandonment in 1914. This is the view north from Woodwards Bridge, just by Crosslanes Lock, in September 1961.

(Bottom) Just a few months later, June 1962, and it had been infilled by the local landowner for what he perceived as a perfectly logical reason. As any thought of restoring the canal was still more than two decades in the future, such actions are understandable.

(Inset) Just a few years later and no sign of the canal now remains.

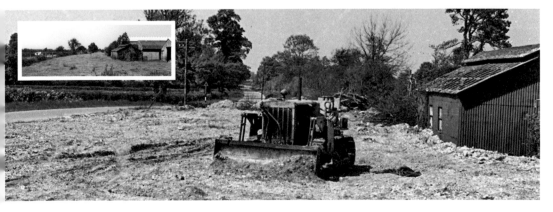

Jack Dalby at the River Key Aqueduct in the 1960s. It was during this time that he was researching the canal and would eventually publish his findings. This was pure research, for the idea of ever restoring the canal would not have entered his mind.

Near the end of the 1990s a sudden panic occurred for the canal restorers. The Key Aqueduct was collapsing and likely to block the river and the local authorities were preparing to have it demolished. A hastily formed working group took up the challenge and completely repaired all the arches, as well as the associated infrastructure.

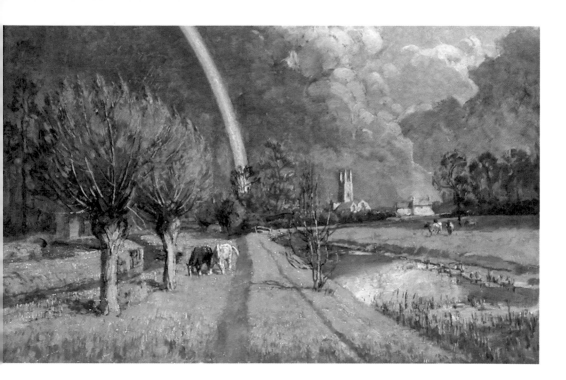

Looking back towards Cricklade, with the River Thames and West Mill on the left in this painting by Edward James Buttar from around 1940. The mill ceased to be used in the late 1800s when it was purchased by the Thames Conservators as a flood preventative measure. Before the opening of the Thames & Severn Canal, boats traded this far up the River Thames. A public right of navigation still exists but, other than the occasional canoe, boats no longer venture far past Inglesham.

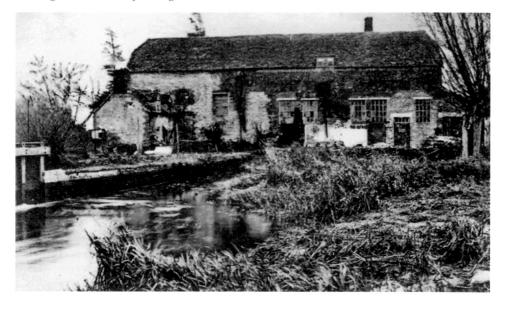

West Mill in about 1900. At the same time as Edward Buttar was painting his picture (in the 1930s), the mill and the miller's house were being demolished.

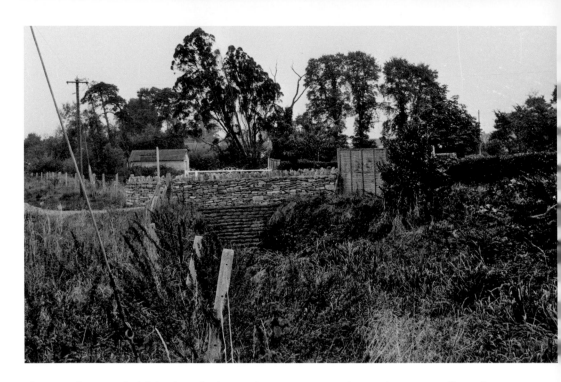

This was the site of a lift bridge which gave farm access over the canal to West Mill. By the 1960s the canal had been culverted, with dry stone walls acting as parapets.

2012 and the canal has completely disappeared, although the line can still be traced through the field. The mill has also gone. Cricklade church is visible behind the trees and the line of willows follows the Thames.

The North Wilts Canal had to cross two rivers on aqueducts: the Thames and the Churn. After abandonment, both of these aqueducts slowly deteriorated until they either collapsed or were demolished. As the old towpath along this section is now a public footpath, the aqueducts have been replaced with footbridges. This one is over the River Thames. At both aqueduct sites remains can still be found of the original structures.

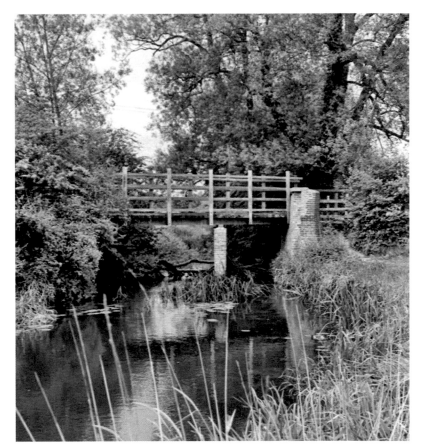

The old canal towpath now provides a pleasant way for visitors to reach North Meadow, which is an old hay meadow and a National Nature Reserve, also a Site of Special Scientific Interest. It is famous for having the largest UK population of rare Snake's Head Fritillaries, which flower in the spring, and attracts a large number of visitors. The flowers are usually at their best during the second and third weeks of April. The meadow is now owned by Natural England, who arrange guided walks around the meadow at weekends when the Fritillaries are in flower. The towpaths here and along the Thames & Severn Canal provide part of a circular walk.

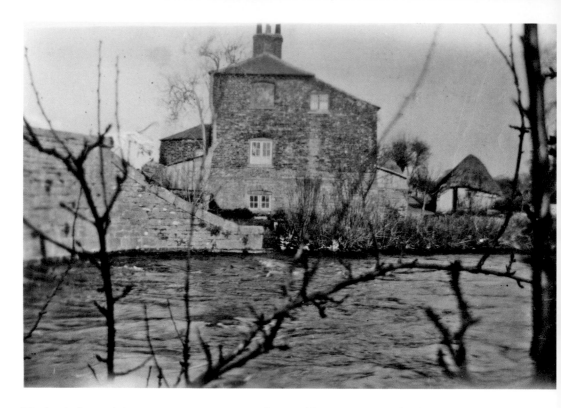

The basin keeper's house at Latton Junction. The canal here is on an embankment, into which is built a flood relief aqueduct. This was essential as the canal crossed the flood plain. Seen here in the 1920s, the water is high, indicating that all the adjacent fields would have been flooded. The small thatched structure to the right was one of several sheds scattered around the basin.

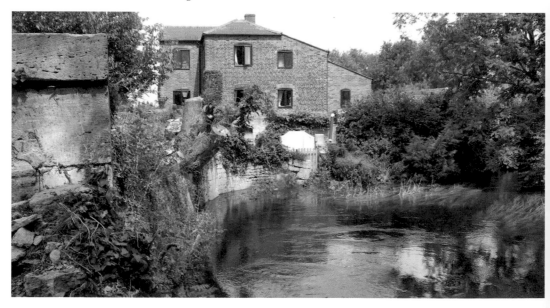

Nothing has changed. This is 2012 and the surrounding fields are again flooded.

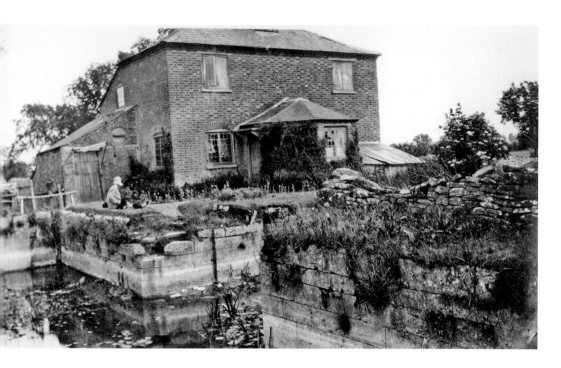

The basin keeper's cottage in the 1930s. There is still water in the basin although the level is low.

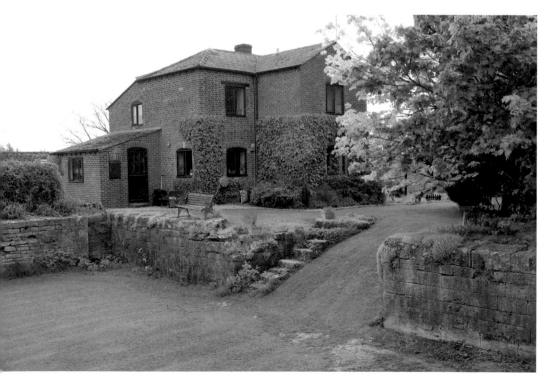

In this photograph from 2010, the cottage has been extensively modernised, the lock has been filled in and the water has gone.

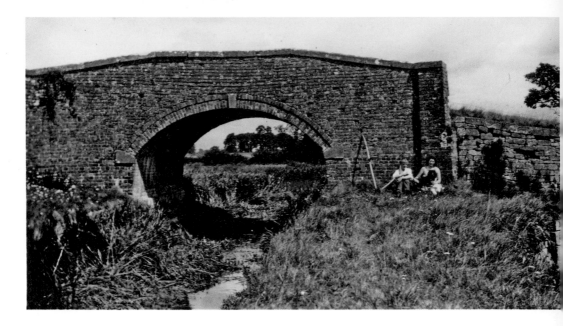

Between the basin and the Thames & Severn Canal an aqueduct carried the navigation over a mill leat. It then passed under the Junction Bridge. As can be seen, it had been a long time since any boats passed under here when this photograph was taken around 1930 and shortly afterwards the bridge was demolished.

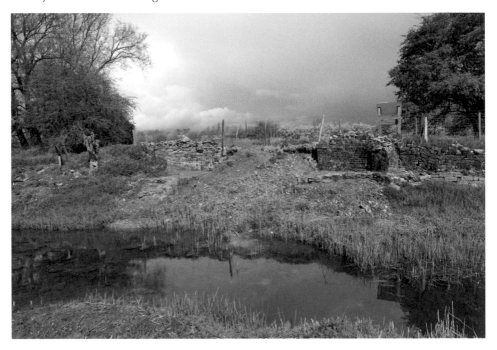

The exceptionally dry weather of 2011 allowed clearance work to expose the remains of the bridge abutments, which appear to be in reasonable condition. It is possible that in the future this bridge could be rebuilt along with the aqueduct to allow boats once more to enter the basin.

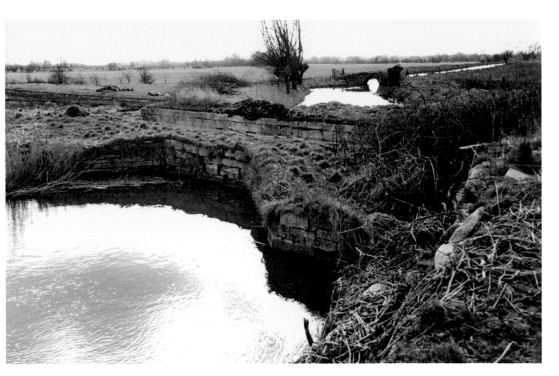

This photograph was taken in the 1950s, from the side of the remains of the Junction Bridge looking up the mill leat across the aqueduct. The leat is remarkably clear of weeds, unlike today, which seems to indicate that the waterway was being well managed. As the bed of the aqueduct was lower than the surface of the leat, a culvert was built beneath it so as not to impede the water flow. The small bridge over the leat is for farm access.

Although the sides of the aqueduct were removed during the 1960s, its base with the culvert underneath still exists, as shown in this photograph from 2012. The culvert is sound but silted up. The farm bridge was also destroyed, leaving only the abutments.

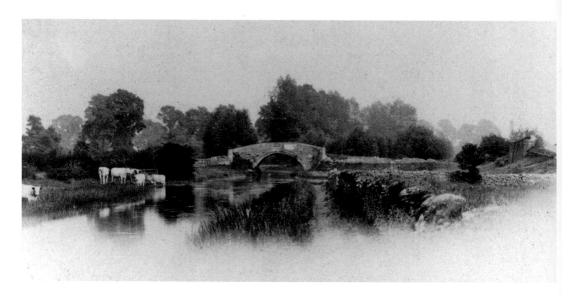

This is a very pleasant rural scene, probably from around 1900, looking east down the Thames & Severn Canal towards Weymoor Bridge with the Junction Bridge on the right.

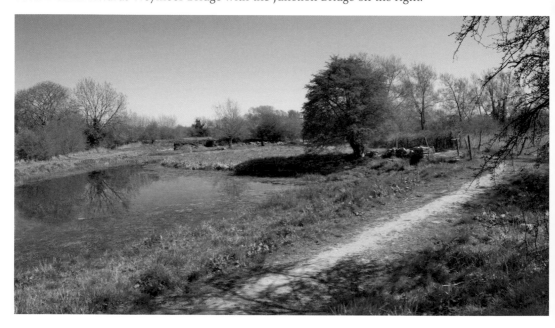

The same view today. Weymoor Bridge was destroyed at the same time as the Junction Bridge, in order not to impede the increasingly larger farm vehicles. As part of the Thames & Severn Canal restoration, the rebuilding of Weymoor Bridge is to start very soon. The site of the Junction Bridge is marked by the information board in this image from 2012.

Swindon to Semington

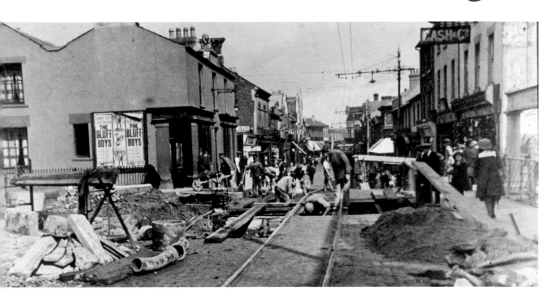

Golden Lion Bridge was demolished in 1918. The lion can still be seen on the roof of the pub that gave its name to the bridge. There is no record of what happened to the bridge components.

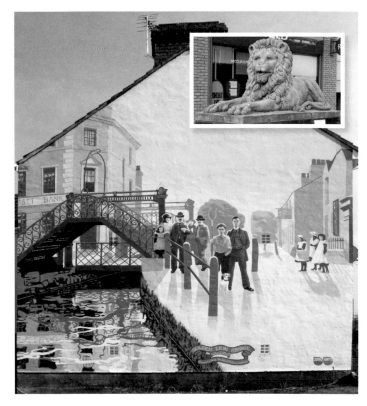

Inset: A replica of the Golden Lion now stands close to the original site in Swindon's Canal Walk in this photograph from 2012.

Over the years local Swindon artist Ken White has painted a number of murals around the town, including several with canal related themes. One of his best known is that of Golden Lion Bridge on the side of a house, not exactly at the bridge site but on Fleming Way near to Whale Bridge, where it is on prominent display. Ken painted this originally in 1976, repainted it in 1983 and again in 2009.

In 2010 Swindon Council erected this water feature close to the site of Golden Lion Bridge in Canal Walk. It attracts a lot of interest from bemused passers-by.

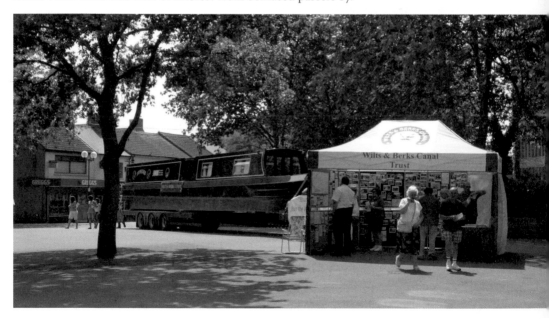

On 4 July 2010 a narrow boat once again appeared in Canal Walk. This was the Inland Waterways Association's 60-foot *Jubilee*, on her way to Beale Park, near Reading, for the National Waterways Festival. The Wilts & Berks Canal Trust was promoting the restoration and the boat certainly attracted attention.

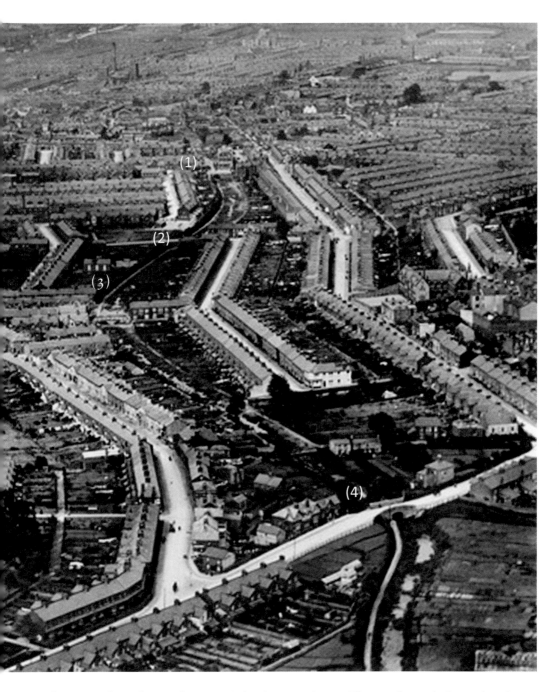

Looking east along the canal into Swindon in around 1920. The canal travels down the picture and Milton Road Bridge (1) can just be seen next to the Central Club. Continuing down the canal, there is Cambria Road Bridge (2) and Marlborough Street footbridge (3) and then Kingshill Road Bridge (4). Proposals to restore the canal include a new section to the left of the original line to rejoin the North Wilts just before it passes under the railway.

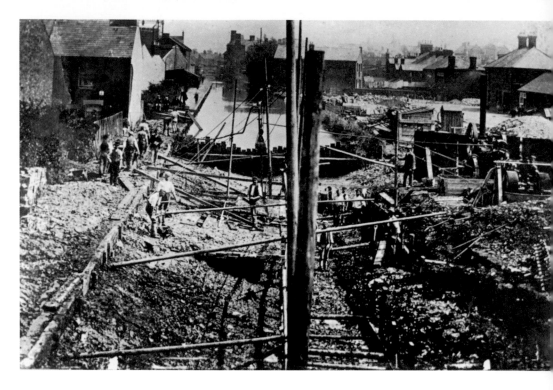

A temporary stoppage just east of Milton Road Bridge (also known as Commercial Road Bridge) to enable work on the foundations of some new buildings in about 1896. With practically no traffic on the canal it is doubtful that this was particularly inconvenient for the Canal Company who, no doubt, claimed compensation.

Canal Walk now runs along the old canal line. This picture is from the east side of Milton Road Bridge, taken in 2012.

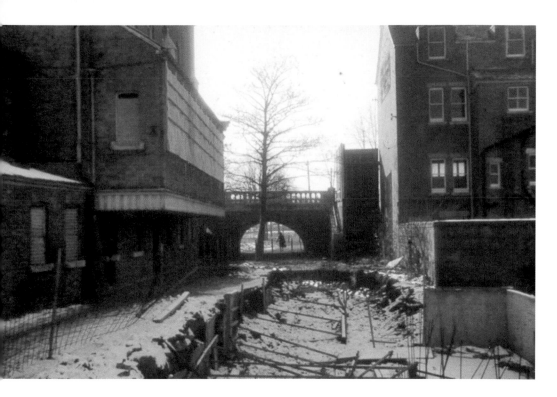

Milton Road Bridge was erected in 1890. It was built to replace Black Bridge. The building on the left (Central Club) is often thought, due to the overhanging extension, to have some connection with the canal, but it did not. The canal bed was infilled and turned into a footpath. This photograph, looking east, was taken in about 1960.

The bridge originally had ornamental stone balustrades but these were replaced in 1981 by brick and concrete balustrades. This image is from March 2012.

Looking west from the site of Cambria Road Bridge on 27 August 1962. The footpath is the old towpath and the canal has been infilled. No boats, but two very nice old cars.

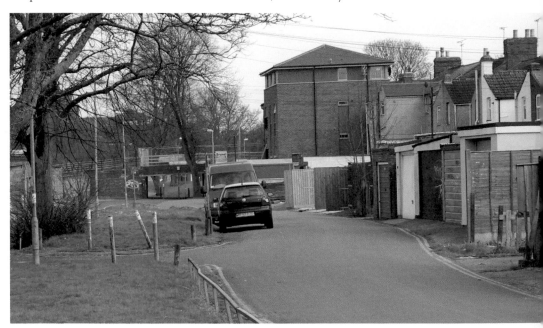

Looking back towards Cambria Road Bridge in March 2012. Many of the old houses on the right still exist. As there is now road access, garages have replaced the back gardens and sheds. The bridge was built in 1877, modified in 1893 and again in 1978.

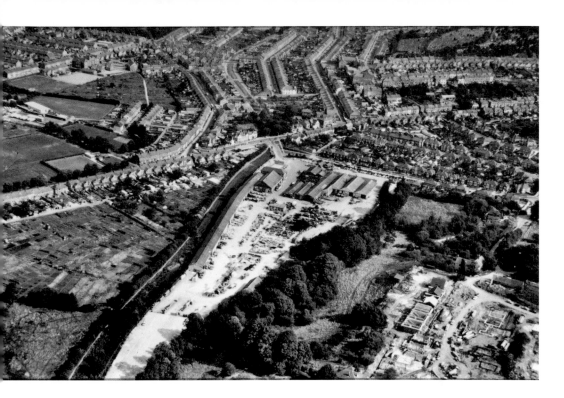

The canal line east from the Kingshill Bridge site (centre top) is now clearly just a footpath. Going the other way (west), the canal still appears to have water in places although by now (around 1960) it would have been very shallow and muddy.

The site of Kingshill Bridge looking west in March 2012. Through the gateway can be seen the beginning of the newly restored section of canal. The restoration plan proposes to bring the canal back across this road to join a new section which will connect with the North Wilts route near where it will pass under the railway.

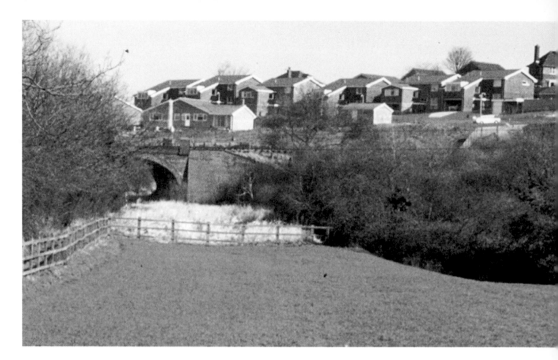

Looking east at Skew Bridge (the old MSWJR line, which is now a cycleway), the canal is totally obliterated in this image from about 1980. Even the River Ray which runs under here beneath an aqueduct is hard to find.

What a transformation. A length of canal down from Kingshill Bridge has been fully restored and the Canal Trust now run regular boat trips in the purpose built narrowboat *Dragonfly*, seen in an image from May 2012. This length of canal will eventually connect to the new main line of the canal.

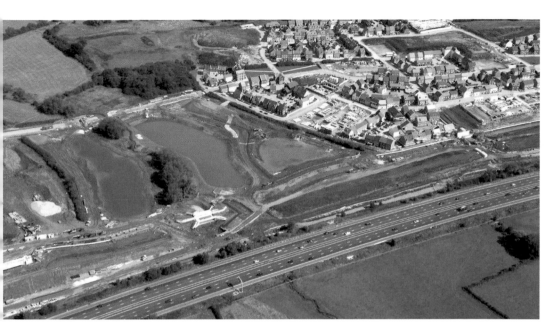

At Wichelstowe a totally new one-kilometre length of canal runs alongside the M4 motorway in this photograph from 2010. As it is impossible for the main line of the canal to find a way through Swindon, the canal will follow the M4 corridor as far as the A419 and, after passing under it, will turn north to rejoin the original line near Bourton. As part of the housing development, the contractors constructed this section which includes one lock and an aqueduct over the Wroughton Brook.

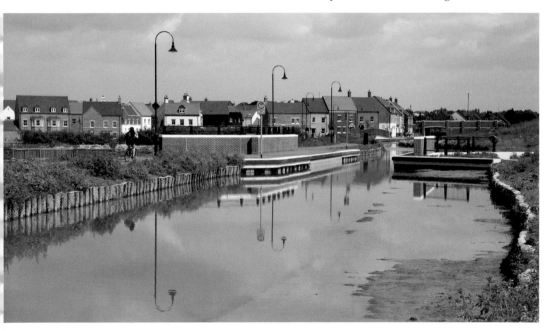

The development was almost complete by 2011 and most of the available housing sold. The aqueduct is in the foreground. Currently Swindon Council is responsible for the management of this piece of water. Not only will it extend eastward but also westward, through another planned development to a point where it is hoped to take the canal under the motorway.

More peaceful times at Wroughton Wharf in about 1960, before the coming of the motorway. The canal ran from bottom left up to the bridge by the house and carried on towards Swindon. The M4 is now just the other side of the building.

Looking from the site of Elcombe Bridge towards the farm building, the route of the canal is defined by the hedge line in August 2011. The M4 is hidden but the houses of Swindon can be seen on the hill beyond.

Looking west from Binknoll Lane towards Royal Wootton Bassett in about 1960, the canal bed is dry and the lock keeper's house stands empty.

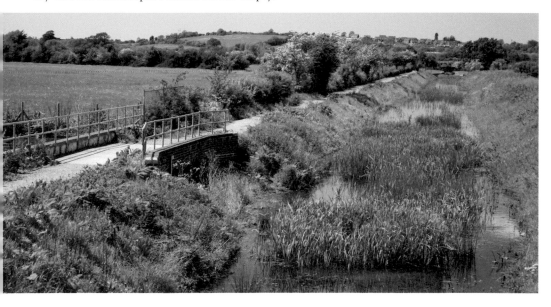

Over the last few years volunteers have brought about a remarkable transformation. The canal has been dredged and re-profiled, and a large spillweir, seen here in 2011, has been constructed in preparation for the possibility of excessive water flooding down from the Swindon summit when the canal is re-opened.

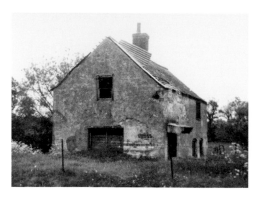

It's not known when the lock cottage was last inhabited, but it had obviously stood empty for many years when these pictures were taken in about 1950. As with many of the other old locks, the bricks from Chaddington Top (Summit) Lock have been robbed out for use elsewhere.

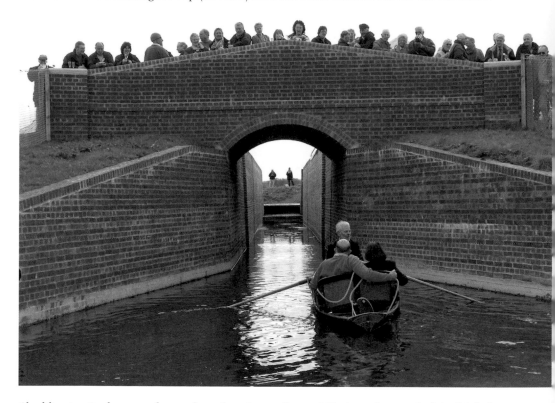

Chaddington Lock can no longer be referred to as 'Summit' lock as the new lock in Wichelstowe already raises the Swindon summit and there will be a need for even more locks to take the canal around the town on the new route following the M4 corridor. After many years of work by volunteers, this lock was completely rebuilt and officially opened on 13 April 2005. In the skiff *Emily* are: Chaloner Chute (rowing), project officer of the Wilts & Berks Canal Partnership; Doreen Darby, chairman of the Wilts & Berks Canal Partnership; and Ken Oliver, chairman of the Wilts & Berks Canal Trust.

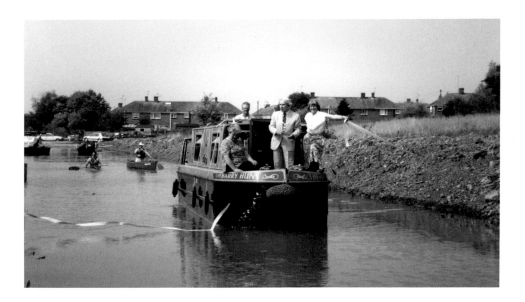

A one-mile length of canal at Templar's Firs, Royal Wootton Bassett, was opened in 1996. This was a landmark for the Wilts & Berks Canal Amenity Group (W&BCAG is now the Trust). It was the culmination of years of work which now provides a local amenity. The *Harry Hunt* was the first narrow boat back on the canal since abandonment and was used for the official opening ceremony.

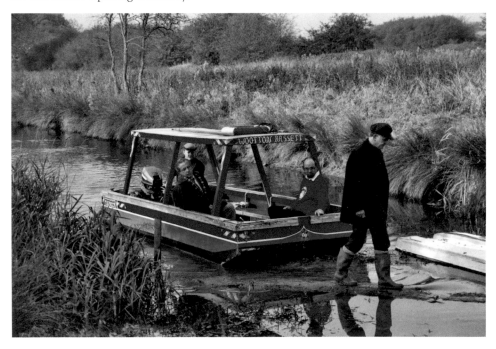

Peter Smith, a director of W&BCAG, is not walking on water in this photograph from 1997. He is walking on a sewer pipe which crossed the canal just below water level and was about halfway down the canal. It prevented boats from using the full length of the waterway. Looking out of the side of *Pioneer* is the late Squadron Leader Tony Davy, who was chairman of W&BCAG, and in the red sweater is John Allen, the vice-chairman.

The concern over the submerged sewer pipe was exacerbated as the 1998 IWA Trailboat Festival was due to be held here and the visiting boats had been promised the full mile. Wessex Water came to the rescue and the pipe was re-located beneath the canal bed in time. Around fifty boats of all types came to the successful event.

John Gould, the legendary waterway campaigner and a vice president of W&BCAG, came along to lend his support to the festival. John, who had worked on canals for most of his life, inspired many people to embark on the 40-year restoration campaign that ended with the reopening of the Kennet & Avon Canal by Her Majesty The Queen in 1990.

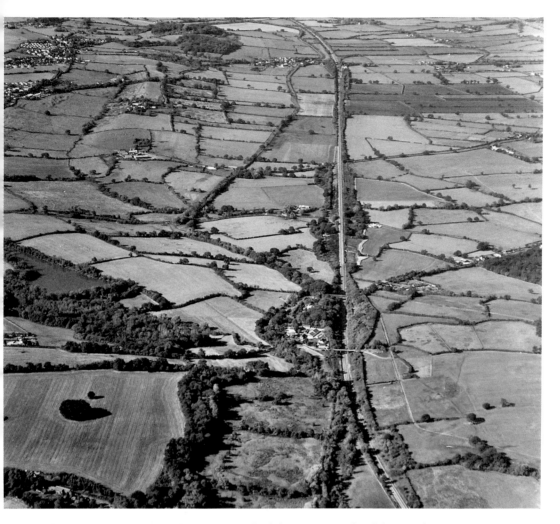

Tockenham reservoir, left of picture, supplied the western side of the canal from the top of Seven Locks. In this aerial view from about 1950 the canal line runs from bottom to top, with Seven Locks halfway up and Dauntsey Lock in the distance.

The reservoir is now a private fishery, but water still flows through the outflow towards the canal line in this July 2012 image.

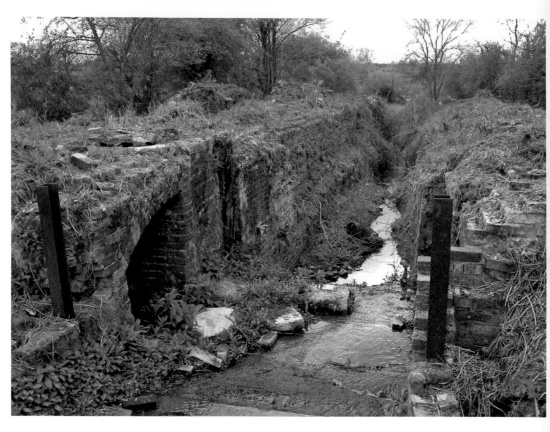

Restoration of the Seven Locks flight is underway. All the locks are in a very poor condition and will have to be totally rebuilt. Lock 4 is seen in around 2008.

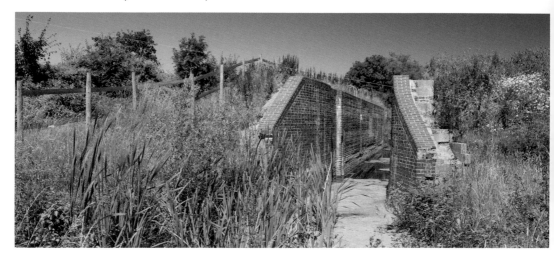

Lock 4 was complete by July 2012, as was Lock 3. Work has started on Lock 2, but cannot be completed until Bowds Lane, which runs across the lock chamber (historically on a draw bridge), is moved beyond the lower gates. Lock 1 has had the undergrowth cleared. Currently access to locks 5, 6 and 7 is a problem for restorers, as the landowners are not yet granting permission for any work to be done on them.

Looking down towards Dauntsey Lock from Bradenstoke (or Clack) Hill in 1905. Hope House (once a pub) is centre left and the Peterborough Arms is almost opposite. The wharfinger's house is on the other side of the lock and the canal, which is clearly in water, runs straight across the picture.

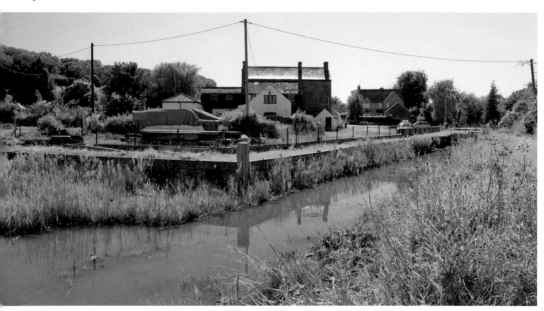

After abandonment Dauntsey Lock and the canal bed were filled in with, among other things, old cars and tyres and had disappeared from view. A new canal company, with the aid of the volunteering groups, has now cleared the canal and rebuilt the lock. They also restored a spillweir along this section. A new wharf has been constructed at the rear of the pub car park and is seen here in July 2012

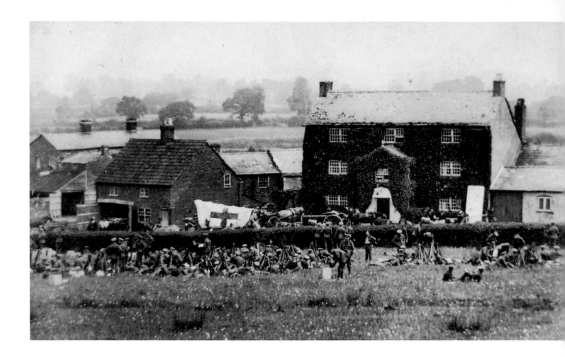

On the far left of the picture is the wharf house, which still exists, and the lock is between it and the residence, facing the road, behind which is the lock keeper's house; both of these have now disappeared. The date of the picture is 17 June 1913 and the troops in front of the Peterborough Arms are the First Wiltshire Regiment, who have halted their march for lunch.

The scene is not vastly different today (July 2012). The lock which had been previously infilled has now been cleared and rebuilt. The road which passes over the tail of the lock separates the two halves of the canal owned by the Wilts & Berks Canal Company. It was recently announced that this road is to be closed while work is carried out on the railway bridge just further along. It is hoped that this may provide an opportunity for the canal bridge to be built which, with the lock in operation, would provide two miles of usable waterway. A new addition to the Canal Company 'fleet' is soon to be launched: an ex-British Waterways tug has been purchased and after re-fitting will enter service as a trip boat, running from just behind the pub.

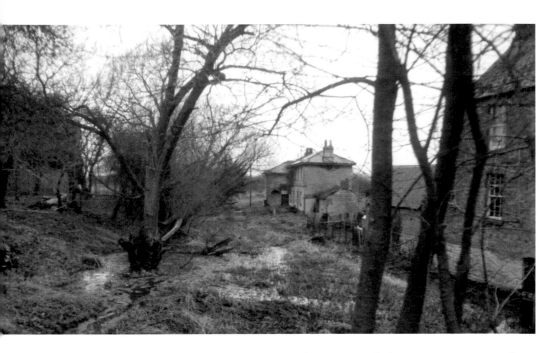

It was in 1994 that Rachael Banyard, an ardent canal restorer, took the opportunity to purchase the canal cottages and two miles of canal from Gordon and Ken Barnes, who were descendents of an old canal family. They had been running a garage business from close by the cottages, and east of the lock the canal had provided a convenient disposal site.

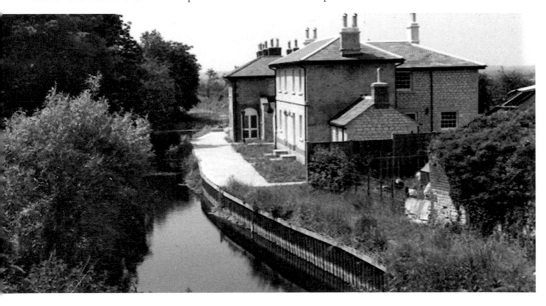

Rachael formed the Wilts & Berks Canal Company and set about fully renovating the cottages. She also began, with the aid of volunteers from WBCT and WRG, clearance work on the canal itself and the rebuilding of Dauntsey Lock. The restored cottages now face clear water in this photograph from about 2000. It should be noted that the Canal Company and the Trust are separate organisations.

West from the cottages the canal was silted up, with many trees growing in the bed, as can be seen in this image from about 1994.

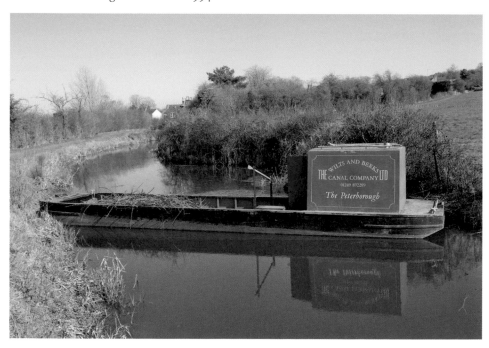

Once again, with the aid of the volunteers, the Canal Company set about clearing the canal. The result is approximately one mile of restored canal. The company work boat proves essential in keeping the canal clear. At the end of the cut a totally new spillweir has been created. *The Peterborough*, the company work boat, is pictured here in 2012.

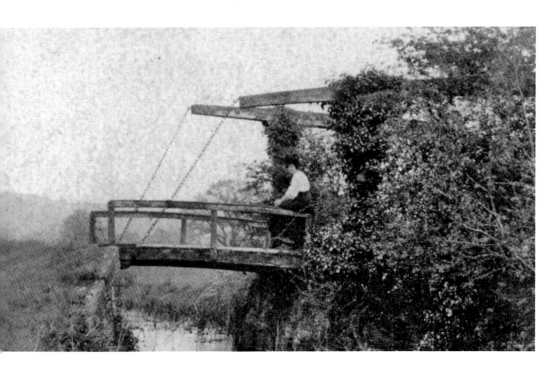

Many of the bridges over the canal were lift bridges similar to this one pictured in about 1920.

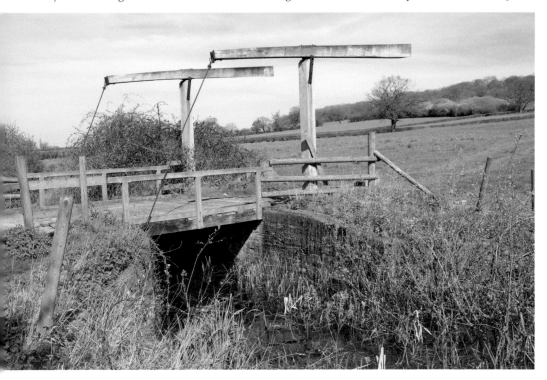

Volunteers built this bridge over the canal just above Foxham Top Lock in the early 1990s and by 2011 it was well weathered in.

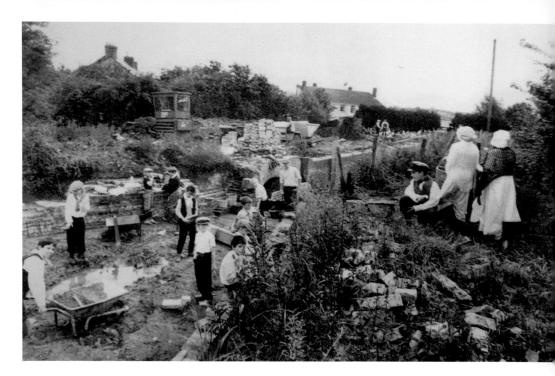

Not the 1790s but the 1990s. Children from Calne are seen re-enacting the building of the canal at Foxham Top Lock. They would have been surprised to learn that children of their age would have been employed by the original canal builders. The lock was actually being rebuilt by W&BCAG volunteers aided by WRG.

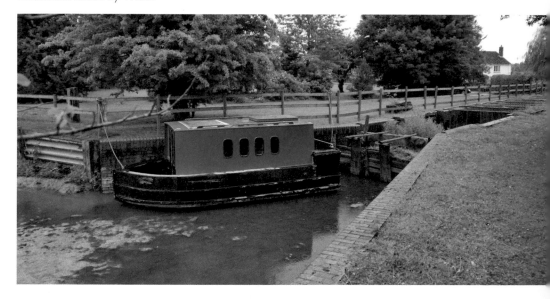

Foxham Top Lock is yet another rebuilt lock just waiting for its gates and paddles to be fitted in this photograph from 2011. However, before this can be done a short length of canal between it and Foxham Bottom Lock will need to be restored, as will the lock itself. This is just another example of the many frustrations of a very complex canal restoration. The boat belongs to one of the local house owners.

In 1745 John Cennick founded a Moravian School for young ladies in East Tytherton; the school survived until 1931. Young ladies from the school are playing on the frozen-over canal near Bremhill Wick Bridge in around 1925.

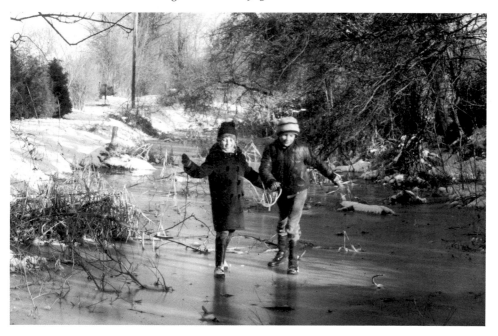

Nothing really changes; fifty years later and these youngsters are on the iced up canal at Challow near Wantage in 1985. This is not something that children should normally be encouraged to do, but the water under them would only have been a few inches deep.

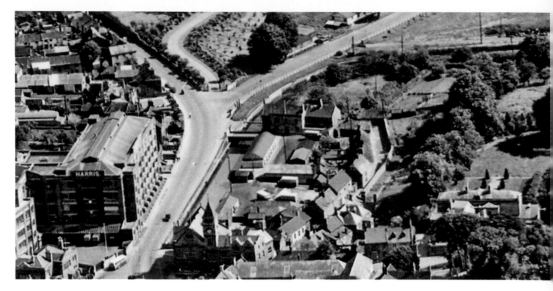

The Calne branch of the canal terminated at a wharf on the River Marden near to the town hall, which is just opposite the Harris factory. In this 1950s aerial view the wharf and buildings are still intact. The river curves to the right and Town Lock is hidden beneath the trees.

The entrance to Calne wharf is seen in 1965, but with little sign of any activity. The Wharfinger's house was officially opened by HRH the Prince of Wales as a local community and arts centre in 1990.

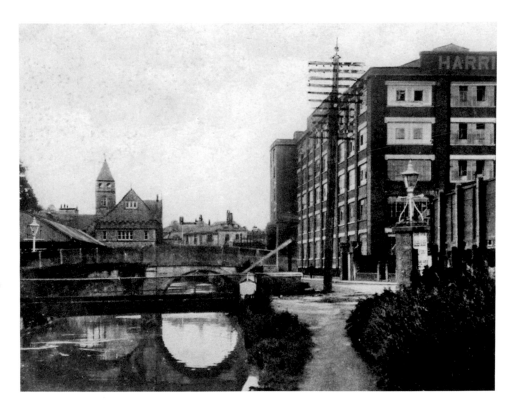

The River Marden with the town hall in the distance in about 1930. Boats would originally have had to pass under the arch bridge to reach the wharf but this is no longer possible as there is a now fixed footbridge across the river.

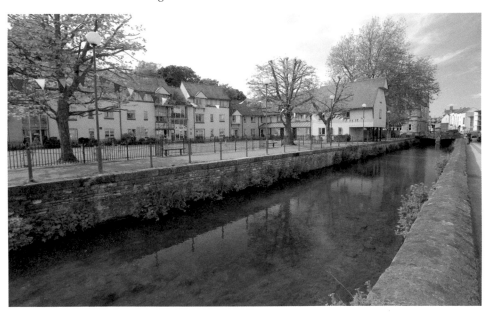

Housing has been built on the original wharf site; the Harris factory is long gone, but the town hall still remains the same in this photograph from May 2012.

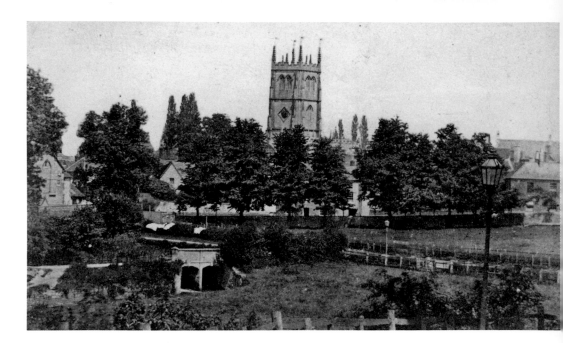

The Hatches in about 1890. These gates controlled the water level of the River Marden above Town Lock. The Marden was a very important feeder for the canal and the water levels had to be carefully managed.

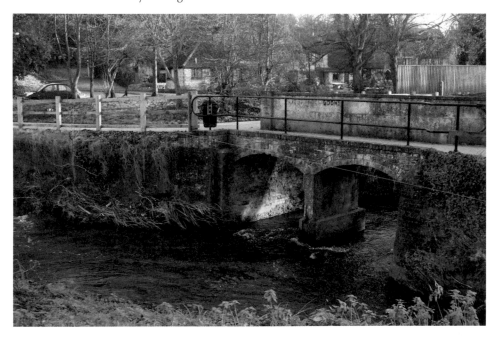

The river is now part of Castlefields Canal and River Park (CARP), whose aims are, 'To preserve, protect, develop and improve the environment of the River Marden Valley and surrounding area and to provide amenities and facilities for recreation and leisure activities for the benefit of the public.' The park also includes Town Lock and a section of canal and is seen here in 2010.

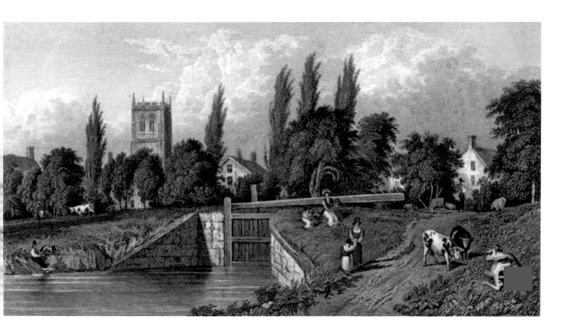

An 1830 engraving of Calne Town Lock.

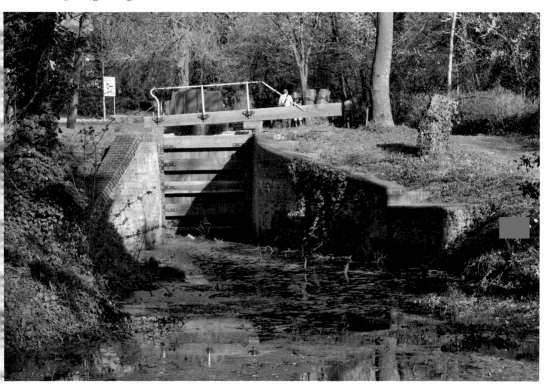

As part of their improvements CARP have had the infilled lock fitted with dummy gates and the bow and stern of a real canal boat placed in the lock chamber. This has proved extremely popular with parents and children. A recent competition named the boat, seen here in March 2012, *Jubilee Queen*. The lock wing walls were previously restored by WBCT and WRG volunteers.

A very sorry looking Chaveywell (or should that be Chavey Well?) Bridge. A typical muddy ditch represents the canal line in about 1960.

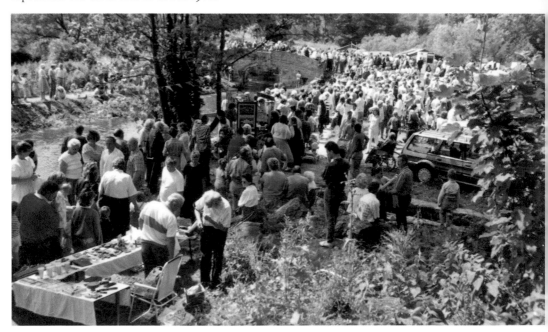

Long before CARP came into existence this was one of W&BCAGs early restoration projects. The bridge was fully restored and the canal cleaned out and since then it has been the venue for several canal days. This was the official re-opening of the bridge in about 1990.

This is the A4 viewed from Blackdog Railway Bridge and the flood is the River Marden overflowing its banks in about 1950. The canal passed under the road, through Blackdog Tunnel, on the higher ground. If the canal not been infilled and had still been carrying water, perhaps this flooding would not have occurred.

The A4 crosses the main line of the canal between Calne and Chippenham, the only indication in this 2011 image being the newly erected road sign. But if you peer through the bushes on the west side you find...

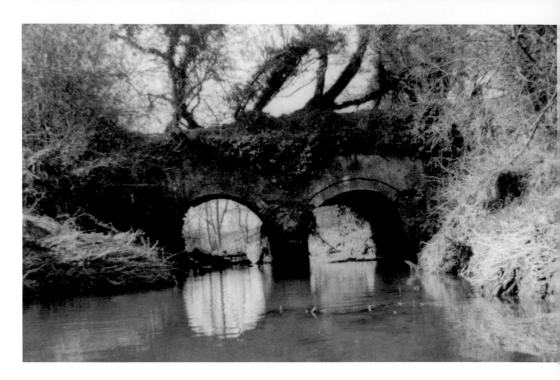

Stanley Aqueduct carried the canal over the River Marden. In 1897 the Canal Company were desperately trying to close the canal but opposition from landowners and Wiltshire and Swindon councils prevented this even though business owners and residents of Swindon supported the move. When in 1901 the aqueduct partially collapsed, draining away a great deal of the water, it prevented any boat movements and effectively closed the canal. This was a very fortuitous occurrence for the Company who, pleading poverty, did not repair the damage and by 1914 the Wilts & Berks Canal was legally closed.

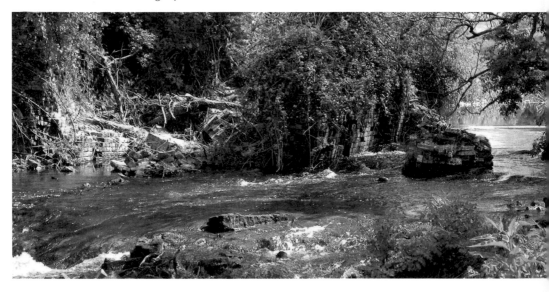

By the mid-1990s both arches had finally collapsed, and now very little of it remains, as can be seen in this April 2012 image.

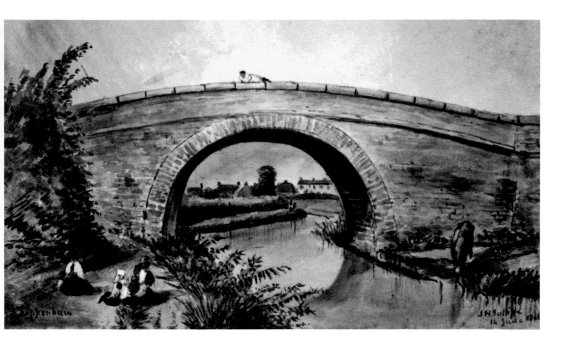

J. H. Joliffe's 1866 impression of Deep Cutting Bridge on the Chippenham branch takes some artistic liberties but seems to show that local people were already considering the amenity value of the waterway. The bridge survived into the 1960s.

The only known picture of Jay's Bridge, from about 1960. The Chippenham branch of the canal has almost completely disappeared and it is not included in the current restoration plan. At some point far in the future it might be possible to reconnect the town to the canal via a link to the River Avon as is proposed at Melksham.

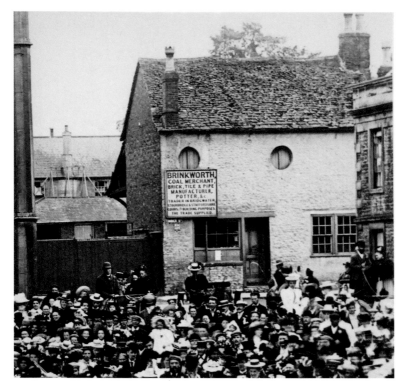

Brinkworth was a coal and slate merchant who also owned several coal carrying boats. This photograph shows Chippenham Wharf and the wharf house as seen from the Market Place in 1897. The occasion was a school fete marking Queen Victoria's Diamond Jubilee.

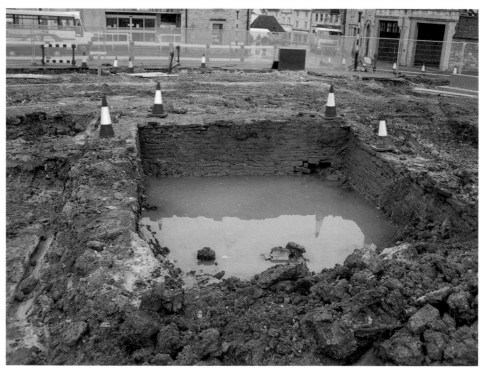

Part of the wharf briefly exposed again in November 2006 during the redevelopment of the bus station which was built on the site in 1977.

For many years, the canal west of the junction with the Chippenham Branch lay overgrown and forgotten. Volunteers started to clear the section and interest was boosted by the construction of a Sustrans cycleway from Reybridge along the towpath towards Pewsham Locks. It is seen in about 2005.

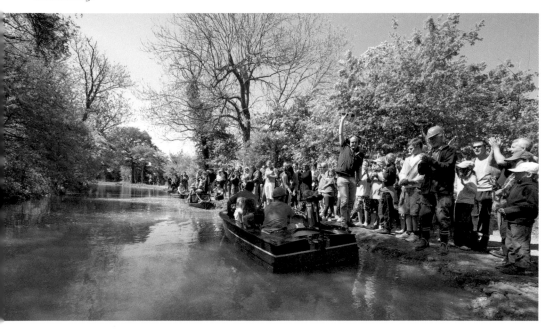

In 2010 serious restoration work, organised by the local branch of WBCT, began along the canal from the bottom of Pewsham Locks to Double Bridge. By May 2011 the section had been re-watered and the opening ceremony coincided with the annual sponsored walk.

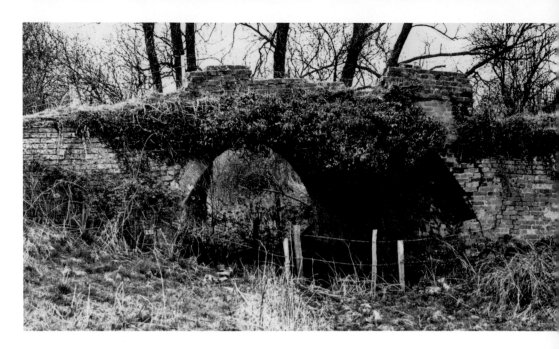

Double Bridge in the 1960s: a typical brick arch bridge but with the roadway twice as wide as normal. Why? Nobody knows, although many theories abound.

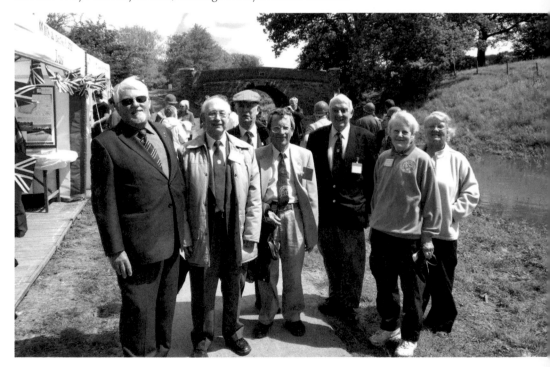

On 26 May 2009 HRH The Duchess of Cornwall officially opened the rebuilt Double Bridge and was introduced to many Trust members. They included this collection of long time members. Left to right: Vic Miller, Neil Rumbol (founder of W&BCAG), Ray Denyer, Chris Toms, Keith Walker, Di Smurthwaite, and Maureen Walker.

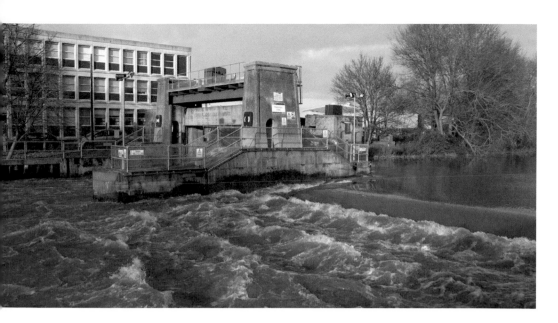

One of the problems of restoring even a very rural canal is getting back through the towns. Melksham presents one such problem; there is just no way back on the original route. An innovative plan is to build a new length of canal from a junction with the Kennet & Avon Canal to the River Avon, and use the river to pass through the town. It will then use a new lock to leave the river in order to rejoin the original line. The locks on the new canal will be 14 feet wide. This plan has the support of the town council as it will revitalise a rather uninteresting waterfront and attract boats into the town. Construction is expected to start in 2013/14. One obstacle on the river is this flood control gate and weir, seen in 2010. A new river lock will need to be constructed.

Close to Outmarsh Farm, looking east in around 1970 towards the old Railway Tavern; the canal passes behind the pub towards the house beyond, which was once the boat building premises of William Large.

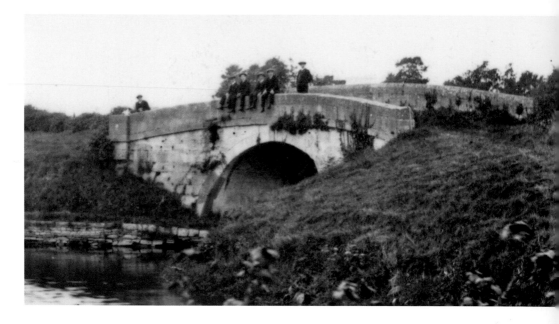

Semington Junction in about 1912. This is the junction with the Kennet & Avon Canal where the boats carrying the coal from the Somersetshire Coal Canal would have begun their journey through the Vale of the White Horse.

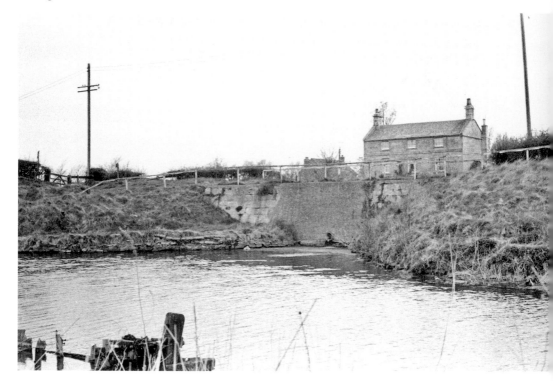

By the 1960s the junction bridge was long gone and the entrance sealed up. The Kennet & Avon was also in a very poor condition, although campaigning for its re-opening was already underway. The impressive building in the background is the Toll Collector's House.

The Kennet & Avon Canal was still disused in the early 1970s, becoming overgrown with weed. After a long struggle the canal was reopened by Her Majesty The Queen in 1990.

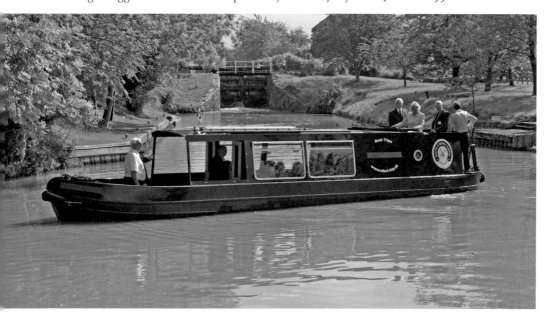

The WBCT have a new trip boat on which HRH The Duchess of Cornwall, who is patron of the Trust, travelled to Semington Junction for the boat naming ceremony. The old junction made a convenient winding point. The boat was named *Dragonfly* on 8 September 2010. The lock in the background is Semington Lower Lock.

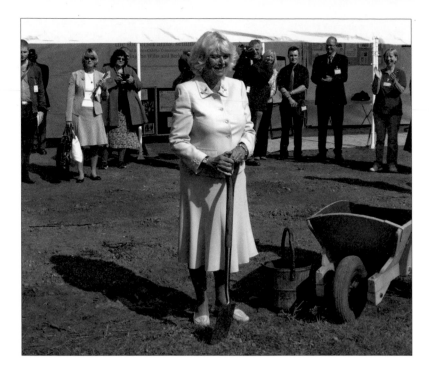

HRH The Duchess of Cornwall cut the first turf at the site of the new junction with the Kennet & Avon Canal near Semington on 8 September 2010. A new length of the Wilts & Berks will join the Kennet & Avon Canal to the River Avon, where it will pass through Melksham before a new lock takes it out of the river back towards the original line.

If you would like more information about the canal restoration, contact the Wilts & Berks Canal Trust: http://www.wbct.org.uk

Acknowledgements

I would like to extend my thanks to all the following for their generous help in assembling these photographs. Barbara Small, Ray Alder, Jon Miles, Vic Stroud, Jan Flanagan, Peter Williams, Neil Rumbol, Peter Smith, G. P. Osbourne, Paul Williams, Brian Stovold, Elizabeth Drury, Martin Boydon, Peter Scatchard, David Banfield, Mike Matthews, John Minns, Chris Naish, John Wilson, Tim Preece, Gloria Loakes, Keith & Maureen Walker, Rachael Banyard, Graham Edwards, the Keasbury-Gordon Photograph Archive and all those others who have offered help with dates and details.

Author's web site: http://www.gentle-highway.info